MISSOURI'S HAUNTED ROUTE 66

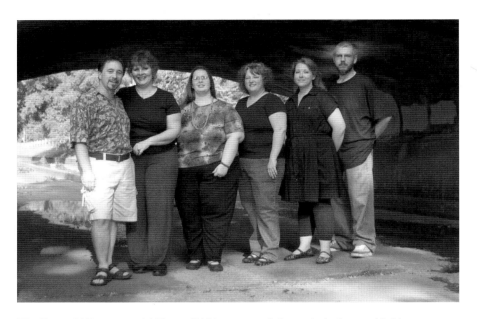

The Route 66 Paranormal Alliance (PAL) team stands beneath the haunted bridge at Phelps Grove Park in Springfield, Missouri. *From left:* Dean Pestana, author Janice Tremeear, Charlene Wells, Jeanna Barker, Alicia Holder, Andrew Muller. *Not pictured:* Ken Brewer. *Courtesy of Steve May.*

Missouri's Haunted Route 66

Ghosts Along the Mother Road

JANICE TREMEEAR

Published by The History Press
Charleston, SC 29403
www.historypress.net

Copyright © 2010 by Janice Tremeear
All rights reserved

Front cover image: Vintage postcard of Missouri's Route 66. *Courtesy of the author.*

Back cover image: Pythian Castle. *Courtesy of Dean Pestana.* Vintage postcard of Missouri's Route 66. *Courtesy of the author.*

First published 2010

Manufactured in the United States

ISBN 978.1.60949.041.6

Tremeear, Janice
Missouri's haunted Route 66 : ghosts along the Mother Road / Janice Tremeear.
p. cm.
Includes bibliographical references.
ISBN 978-1-60949-041-6
1. Ghosts--Missouri. 2. Ghosts--United States Highway 66. 3. Haunted places--Missouri. 4. Haunted places--United States Highway 66. 5. Folklore--Missouri. 6. Folklore--United States Highway 66. 7. Missouri--History, Local. 8. United States Highway 66--History, Local. I. Title.
BF1472.U6T76 2010
133.109778--dc22
2010031405

Notice: The information in this book is true and complete to the best of our knowledge. It is offered without guarantee on the part of the author or The History Press. The author and The History Press disclaim all liability in connection with the use of this book.

All rights reserved. No part of this book may be reproduced or transmitted in any form whatsoever without prior written permission from the publisher except in the case of brief quotations embodied in critical articles and reviews.

For my family. All of you.

My mom, Thelma Rice, survived two husbands, heart trouble and a small stroke this past spring that had us fearing we'd lose her, too. Twenty years my senior, her mind is still agile and sharp. I love you, Mom. I want to be as strong as you are when I grow up.

Robert and Pat Routt, my brother and sister—they followed me on our wild childhood adventures out on the farm and have lived to tell about it. Jumping from the hayloft and having the wits scared out of us over Jack the Giant Killer brought us closer together and just a tad bit crazier.

My children: the most special people in the world and my heart's joy. Jennifer, Charlene and Nathaniel often find themselves sucked into my schemes and love me anyway. You are my world, and I'm so proud of you.

My grandchildren: Geoffrey, Madison, Tonia and Erica—a brand spanking new, innocent generation for me to corrupt with granny evilness or spoil them with love. They are the lights of my soul.

Extended family includes the members of Route 66 PAL. We have bonded in trust and friendship and have one another's back in sometimes physically dangerous situations. They've cheered me on every step of the way during this project.

My belly dance sisters of Project Vagabond and Gypsy Sol who've put up with my being distracted at rehearsals and put me through the paces, making me sweat out the stiffness of too much computer time and the frustration of deadlines. These twelve strong, magnificent women have proven this many females can gather several times a week and travel in cramped situations without resorting to the predatory nature that TV and movies portray as female nature. I consider myself blessed to be a part of your journey.

My soul mate, Dean—he believes in me. He supports me and puts up with my love of anime and RPGs. He joins me on my crazed missions, or perhaps with his pirate nature he's abducted me into his world and I just haven't realized it yet. Thanks sweetheart!

CONTENTS

Acknowledgements 11
Introduction 13

1. St. Louis, Missouri 19
SS *Admiral* 21
Union Station 23
The Caves of St. Louis 25
Chase Park Plaza Hotel 28
Soulard Market 29
Laclede's Landing 30
Lemp Mansion 31
Hitchhike Annie 36
The Feasting Fox 39
Forest Park 39
Old Courthouse 41
Zombie Road 42
Shaw's Garden 45
Webster Groves 49
Jefferson Barracks 50

Contents

2. Eureka and Pacific, Missouri	55
Six Flags Over Mid America	55
Pacific	56
The Diamonds–Tri County Truck Stop	57
3. Defiance and Union, Missouri	63
Daniel Boone Village	63
Union	66
4. Morse Mill, Missouri	67
5. Stanton, Missouri	75
Meramec Caverns	75
6. Sullivan, Missouri	79
Harney Mansion	79
7. Rolla, Missouri	83
Goatman's Grave	83
Devil's Elbow	85
Fort Leonard Wood	87
8. Springfield, Missouri	89
Gillioz Theater	92
Landers Theater	93
Walnut Street Inn	96
Pythian Castle	97
Maple Park Cemetery	102
MSU	103
Springfield National Cemetery	109
Wilson's Creek National Battlefield	109

Contents

9. Buffalo, Missouri — 111
Rack It Pool Hall — 111

10. Carthage, Missouri — 113
Grand Avenue Bed and Breakfast — 113
Kendrick House — 113

11. Joplin, Missouri — 117
Freeman Hospital — 117
Peace Church Cemetery — 118
Prosperity School Bed and Breakfast — 118
Joplin Spook Light — 120

Bibliography — 123
About the Author — 125

ACKNOWLEDGEMENTS

Thanks go out to many people for their part in making this book happen: Route 66 Paranormal Alliance, Alicia Holder, Andrew Muller, Jeanna Barker, Charlene Wells, Ken Brewer and Dean Pestana. The team encouraged me from the beginning and helped with gathering information.

Thanks Jeanna for your research and the drawing of Rachel.

Charlene spent hours getting me stories not found elsewhere and writing them down for me.

Dean was *there*, in all ways possible, driving with me to sites, taking pictures, scanning photos, tagging photo captions and digging for the tale on Goatman's Grave, the one story everybody knew but no one seemed to know the exact location. He brought me tea and rubbed the knots from my sore shoulders after I hunkered over the keyboard for hours. He's the one who's had to put up with me when I've gotten growly.

Thanks to Visnja McCullar for her experience at the Daniel Boone Village.

Thank you Jason of SNIPE for the Goatman's Grave accounts.

To Pat Brown Bailey for use of her story and photo of the Springfield National Cemetery.

To Tammy Preston for the MSU stories—together, Tammy and Charlene provided me with the wonderful Killer Squirrels legend I had to include for being one of the most unusual bits of haunted lore you'll come across.

Thanks Robert Preston for converting the stories to PDF files so my computer would open it.

Acknowledgements

Dan and Sherri Terry: Dan is Spookstalker, a former police officer with several paranormal investigations and books to his credit. The Terrys sent me information on their findings at Harney Mansion, Tri County Truck Stop and Prosperity Bed and Breakfast.

Steve May for his photography of Route 66 PAL at Phelps Grove Park by the haunted bridge.

My editor Ben Gibson for contacting us—he asked if I thought there were enough tales of haunted locations along Route 66 to make a book. I answered, "Heck there's enough ghost stories here in Springfield to make a book." And so it began.

Bill and Chris Bryant for allowing Route 66 PAL to be the first group to discover the haunted Rack It, and Chris's story on the Joplin Spook Light.

Tamara Finocchiaro and Tim Piland for the history and tour of the wonderful Pythian Castle. Tamara is a gracious hostess, and Tim's accounts of the happenings in the castle would inspire a movie.

Thank you, Philip and Christopher Booth and Spooked TV, for the *Children of the Grave* footage and information on Zombie Road and Pythian Castle. Your photos are awesome. As busy as the Booth Brothers are within the filmmaking industry, they are always cordial and accessible. Love ya guys! Namaste.

Avoa, for allowing me to take up a semipermanent residence on her computer.

INTRODUCTION

Route 66 has an illustrious history. In 1921, Missourians passed the Centennial Road Law to link all of the state's county seats. Before, America's highways were poorly labeled. Travel was extremely difficult and often dangerous.

To solve this problem, a road numbering and naming system was devised. The plan was to have major highways running north to south be marked in odd numbers, with east to west highways ending in the number zero. One major highway, Missouri State Road 14, linked the county seats from St. Louis to Joplin.

State Road 14 was to become part of Highway 60, which ran from Chicago to Los Angeles, passing through several midwestern states, including Missouri. Kentucky objected; the state leaders demanded a major highway be numbered with a zero even though no transcontinental roads passed through the state. Kentucky wanted the highway between Virginia Beach, Virginia, and Springfield, Missouri, to be numbered Highway 60, with the section of the road to Chicago to be numbered Highway 62. The Bureau of Public Roads agreed.

B.H. Piepmeier, chief engineer of the Missouri State Highway Department, sent a telegram to the Bureau of Public Roads noting that if the bureau submitted to one state's demands on the numbering system, other states would follow. Piepmeier wanted the highway to remain 60 since this was the established designation for major highways.

Introduction

Months of discussion followed, and Piepmeier met the chairman of the Oklahoma Transportation Department, Cyrus Avery, in Springfield, Missouri, on April 30, 1926, to talk about the highway system.

Avery noted that the number 66 had not been assigned to any U.S. highway and agreed 66 was more appealing than the name Route 62, which Kentucky suggested for the section of road between Chicago and L.A. A telegram was sent to the Bureau of Public Roads, and federal officials agreed.

The federal highway numbering system was established on November 11, 1926, and the road between Chicago and Los Angeles became Route 66. Road signs went up the following year.

Once, old wire roads built for the telegraphs were little more than gravel or graded dirt, with a few areas out west covered in wooden planks. Paving of Route 66 was completed in 1938.

The new road was the way west for many who sought a new, better life in California. Trucks transporting goods along the highway during the Dust Bowl years brought relief to many small towns along the way, creating many small mom and pop businesses. Small, boxlike cabins offered shelter to those choosing not to stay in a downtown hotel. Auto camping appealed to the middle and upper classes as they sought to "See America First." People experienced the feeling they were kings of the road, exploring new land.

Tourism blossomed in the '30s. Dorothea Lange's photo of a loaded automobile in her *American Exodus* was captioned "Covered Wagon, 1939 style."

Night travel was dangerous and a novelty before the thirties. The thrill of exploration combined with dangers of the unknown, strange locations, crooked mechanics, speed traps and dubious roadside food. By World War II, Route 66 was fully paved. Serving as a main route for transporting military equipment, the highway at Fort Leonard Wood in Missouri expanded to handle the traffic.

The route was also called by many names, including the Great Diagonal Way, the Will Rogers Highway, Main Street of America, Bloody 66 in Missouri and, from 1968 through 1969, a forty-mile strip of 66 east of Tucumcarito—the Texas border—was dubbed Slaughter Lane by the locals due the many deaths and injuries brought by the increase of traffic on the narrow two-lane highway.

John Steinbeck dubbed it the Mother Road in *The Grapes of Wrath*, giving it the feminine, nurturing label. Bobby Troup wrote a tribute to it that has been recorded many times by several artists. It even earned a TV series during the sixties starring Martin Milner, George Marharis and later Glenn Corbett.

Introduction

The fifties saw tourism boom along Route 66. Roadside attractions grew with teepee-shaped motels, caves advertised on the sides of barns, reptile farms, curio shops, frozen yogurt and fruit stands. Fast-food eateries began because of Route 66 with the first drive-through restaurant, Red's Giant Hamburgs in Springfield, Missouri, and the first McDonald's in San Bernardino, California. Individual motel cabins dotting the road began to disappear in favor of the more economical U-shaped configuration of the motor courts. Semicircular drives offered customers easy access to the motel office and their rooms. The central court with a playground gave relief from the hot rooms. After the war, air conditioning drew in customers and neon signs lit the night, attracting the weary who traveled down Route 66.

The end for Route 66 came when President Eisenhower signed the Interstate Highway Act. The first major bypassing of Route 66 came in 1953 with the Turner Turnpike. New interstates continued to bypass cities with wider lanes and more speed for travelers.

Missouri officially requested the designation of Interstate 66 for the highway between St. Louis and the Oklahoma section to preserve the identity of businesses of Route 66. The designation was denied. Route 66 was officially removed from the highway system on June 27, 1985. It spanned 2,448 miles from Chicago, Illinois, through Missouri, Kansas, Oklahoma, Texas, New Mexico, Arizona and California, ending in Los Angeles.

Many portions of Route 66 became the business loops of the towns and cities they passed through. Some sections are the frontage, or outer roads.

Arizona and Missouri formed the first of the Route 66 Associations in 1987 and 1989, respectively; other states soon followed. In 1990, Missouri declared Route 66 a State Historic Route, placing the first historic marker in Springfield, Missouri, on Kearney Street at Glenstone.

Route 66 has grown into a myth-like stature. Buildings have been restored and signs rescued and preserved. Vintage postcards of Route 66 sell for a good price; collectibles are the rage. Actual Route 66 road signs can range in the thousands of dollars.

The grand lady wound its way into eight states and prospered for nearly sixty years. Towns thrived and then died as the interstate forgot them and life sped by. Small towns sat decaying.

But ghosts are making their presences known. They are found in hollowed-out hotels of a once thriving resort town, walking the streets of amusement parks and garden paths and visiting patrons of a St. Louis hotel–dinner theater. Shadow people wander through a nearly forgotten Missouri town, hang around college campuses and lurk in one of Missouri's castles.

Introduction

Caves and bridges are haunted; graveyards and roads boast vanishing figures.

Route 66 lives on—the associations and fans strive to protect and preserve it.

I was born in St. Louis and lived in Missouri the majority of my life. Like so many of my generation, I grew up riding the grand road in the back of my parent's car, getting our kicks on "Route 66."

Back in the day before seatbelt laws, we kids slept in the backseat and on the floorboards atop blankets and pillows, even in the wide back window.

We laugh about the time when Pat, the baby of the family, was sleeping in the window and dad slammed on the brakes. I don't remember why he stopped so suddenly, but I remember my sister flying out of the back window and crashing down onto Bob while he was sleeping on the floor.

I remember the stories of ghosts and treasure in the caves the family would visit, the ghosts of the big mansions in St. Louis and the Spook Light. When have I not heard of the Joplin Spook Light? What I heard about as a kid, I seek to understand as an adult.

While I do belong to a team of people who conduct paranormal research, the purpose of this book is neither to scientifically prove nor disprove their existence. Tales of spirits have been a part of human culture for as long as

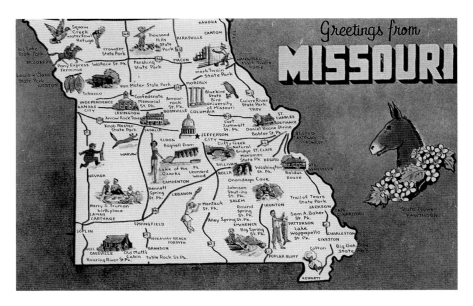

Vintage postcard of the state of Missouri, with Route 66. *Courtesy of Janice Tremeear.*

Introduction

there have been humans, and that, in a sense, makes ghosts real, at least on an emotional level.

Human nature thrives on the possibility of life after death, hoping our loved ones are still near.

We enjoy a good shudder. Ghosts allow us to stand up to the unknown and scary, overcoming the true evils in our lives. Proclaiming a firm disbelief in the existence of ghosts promotes the idea that we are intelligent, well-educated beings and well above the roots of mankind's beginnings.

The Mother Road's ghosts are alive and well. Not every location along Route 66 is mentioned in this book. Some have entire volumes written about them. I have included some of the famous sites, but my primary purpose was to search out lesser-known tales. To my knowledge, some of the stories gathered here have not appeared before in print. This book will follow the ghosts of Route 66 in Missouri, taking a few short side trips off the Mother Road.

CHAPTER 1
ST. LOUIS, MISSOURI

Popular theory in paranormal television shows states spirits are drawn to or able to manifest themselves if certain conditions are met. Lightning storms give off energy, allowing the ghost to draw energy to manifest. Batteries are drained from equipment for the same reason. Electricity in the human body is a source as well. Water, limestone and quartz or buildings of brick and stone can all harbor ghosts because of stored energy. Violent crimes can spark a haunting, causing the person to remain earthbound. Areas where several people died can hold spirits, such as battlefields and hospitals.

St. Louis bears all the appearances of a prime breeding ground for earthbound spirits. The ground is limestone and shale. Most paranormal researchers agree that water and limestone play a big role in the physical manifestations of spirits. St. Louis crouches atop a vast maze of limestone caves; perhaps more caves exist beneath this city than any other, and St. Louis County is perched over a recorded 127 caves. The Mississippi runs the length of the city bordered by the Missouri and Big Rivers.

The Hopewell Indians settled the land as early as 400 BC and built earthen mounds for their homes. These mounds still remain in Cahokia, Illinois. They are huge—the Midwest's own version of Mayan grounds or pyramids. Gazing up in awe at the mounds, I've marveled at their construction.

The Mound City, as St. Louis is called, saw a fire that burned four hundred buildings and fifteen city blocks in 1849; in the same year, the cholera epidemic killed nearly 10 percent of the population. On May 27, 1896, the third-deadliest tornado in American history touched down six miles east of

Eads Bridge, moving from the northwest edge of Tower Grove Park into East St. Louis and leaving hundreds dead and at least one thousand injured; it also caused about $10 million in damage.

On September 29, 1927, the twenty-fourth-deadliest and second-costliest tornado struck, with 79 dead and 550 injured. On February 10, 1959, 21 died and 345 were injured from the sixty-sixth-deadliest tornado.

I visited the 1959 tornado devastation when my parents took us into what remained of the portion of St. Louis affected by the storm. I remember sheared-off sides of buildings, furnishings hanging from apartments, clothing draped on torn walls and people digging through the rubble. I could see inside the rooms and wonder at the portions untouched a few feet beyond the destruction—debris everywhere made the area appear like a place out of an apocalyptic movie. Images were burned into my six-year-old mind.

In 1993, a five-hundred-year flood affected nine states, with fifty dead, seventy thousand evacuated and fifty thousand homes destroyed. A large part of the St. Louis area was underwater, and many people I knew volunteered to sandbag near homes and businesses. A five-hundred-year flood is one that has a one-in-five-hundred chance of happening in any given year, a one-in-ten chance over a period of fifty years or a one-in-five chance of occurring in a century.

Along with natural disasters, St. Louis was home to at least five gangs during Prohibition—with gang-style executions taking place within the city.

Named after a seventeen-mile section of the Mississippi River that produces white water rapids over a series of rocks in the river, the Old Chain of Rocks Bridge is 5,353 feet. Built in 1929 at a cost of between $2 million and $3 million, it is one of the longest continuous steel-truss bridges, connecting St. Louis to Edwardsville, Illinois.

The bridge has a twenty-two-degree angle in its middle, allowing southbound riverboats to avoid the water towers and pillars supporting the bridge. The toll was a mere five cents in the beginning, rising with the times and ending after the bonds on the bridge were paid off.

Route 66 was part of the bridge in 1936 until 1968, when the toll-free bridge of Interstate 270 opened.

Once in Missouri, travelers could visit the Chain of Rocks Park, later known as the Chain of Rocks Fun Fair.

I don't remember the bridge toll, but I thought the water intake towers were cool. Holiday Hill Park, Chain of Rocks and the Forest Park Highlands were some of the most wonderful fantasylands a kid could play in while I was in town visiting grandma and grandpa in the big city of St. Louis.

Today the park is gone, a victim of two major fires within four years and the public wooing from the upstart amusement park out in Eureka, Missouri—Six Flags over Mid America. Chain of Rocks Fun Fair closed its doors on the day the Screaming Eagle roller coaster was inaugurated at Six Flags.

The Chain of Rocks Bridge closed and was left to rot until 1981, when the movie *Escape from New York* with Kurt Russell filmed scenes in St. Louis on the bridge and inside the abandoned Grand Hall of Union Station and Fox Theater. At the time of filming, areas of St. Louis—and East St. Louis, Illinois, in particular—had become extremely run down. East St. Louis had suffered a fire that burned out several blocks, and the empty buildings of St. Louis fit John Carpenter's idea of a setting for New York City as a post-apocalyptic city turned prison.

Sixteen years after Kurt Russell and Isaac Hayes raced across the bridge, it began life anew as a walking and bike trail. Bridge hours are limited because of dangerous access on the Illinois side and the April 4, 1991 murder of the Kerry sisters by four men.

St. Louis is the Grand Dame of Missouri. It is a city of firsts. It has the first cathedral west of the Mississippi, Old St. Louis Cathedral; St. Louis University, first university west of the river; the first commuter community in the suburb of Kirkwood; the first corporation in the United States to engage in retail sales, Simmons Hardware Company; and Susan Blow, who began the first public kindergarten in the nation in 1878.

Francis Field was the first concrete stadium in the United States, built for the 1904 Olympic Games, also a first in America. Eads Bridge is the first arched steel-trussed bridge in the world and the first railroad bridge over the Mississippi. The first skyscraper took shape as the Wainwright Building. And it's said the first edible, walk-away ice cream cone was invented at the 1904 St. Louis World's Fair.

SS *Admiral*

In 1907 in Dubuque, Iowa, Dubuque Boat constructed a steamboat with four large boilers housed in a hull 308.0 feet long, 53.8 feet wide and 7.6 feet in depth.

Above the hull, the ship measured ninety feet wide to accommodate the single paddlewheel. Known as the *Albatross*, owned by the Louisiana and Mississippi Valley Transfer Co., it sailed to Vicksburg, Mississippi, to carry sixteen railroad cars.

In 1920, it sailed back to Keokuk, Iowa, to be placed in dry dock. The *Ripley* Boat Co. made the *Albatross* a marvel of the times by extending its hull to 365 feet.

Streckfus Steamers bought the *Albatross* in 1937, turning it into a river excursion boat. It sailed to St. Louis. In 1940, it dry-docked for an upgrade—its design borne from the mind of Mazie Krebs, a fashion and advertising illustrator for Famous Barr.

Mazie had designed another ship for Streckfus Steamers, the *President*, which took to the river in 1933. She wanted a change from the wooden gingerbread of riverboats and the art-deco style met with the approval of Captain Joseph Streckfus, who was looking for a radical new design.

After two years of construction, the new ship was still a mystery. It was renamed the *Admiral* and, when unveiled, boasted another expansion to its hull. It measured 374 feet long, the length of a city block. The steel hull had seventy-four compartments; eleven could be flooded with the ship remaining afloat. The *Admiral* had five decks, carried 4,400 passengers and was recorded as the largest inland cruise ship in the world. It was the first cruise ship to be fully air-conditioned.

I rode the *Admiral* when I was twelve. It was beautiful, sleek and silver. I spent the two-hour tour exploring every inch of the ship I could get to.

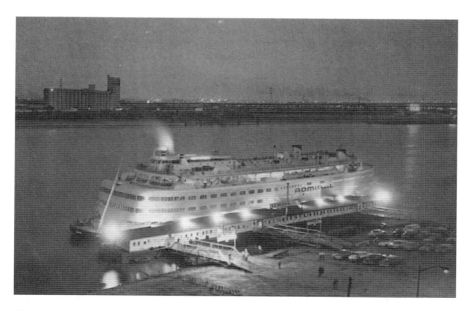

Vintage postcard of the SS *Admiral*, St. Louis, Missouri. *Courtesy of Janice Tremeear.*

I watched the huge arms pumping, propelling the ship through the water. The arcade beckoned. Above decks we stood at the rail, watching St. Louis fade on the horizon. The dance floor was amazing; it was the largest floating dance floor—all gilt and glitz—with padded blue doors, pink and blue pipe lighting. The ladies bathroom had famous movie stars' names on the doors and was something out of a posh movie set.

We ran all over the ship; Mom and Dad relaxed in the ballroom. On the dance floor in my white go-go boots, peacock pattern minidress and waist-length, green and blue disk necklace, I twisted, did the jerk and the swim and I boogied with the best of them to Tommy Roe's "Hanky Panky."

Bob was on the dance floor with me while Pat ran up and down the stairs. Pat called Mom and Dad over to watch us. Bob became quite shy and stopped dancing. Sliding across the floor in my slick-soled boots, I wound up on my tush. Bouncing back up, I pretended I meant to do that.

I only wish I still possessed a fragment of that youthful energy.

We came home loaded with souvenirs, memories and the desire to return. Unfortunately, I never sailed on the *Admiral* again.

Declared unsafe for the river it was turned into a casino—its engines stripped. Its glory faded as did the heyday of Route 66.

I wasn't aware of the *Admiral*'s resident ghost. A man named Fred Williams was the porter in the men's restroom on the first deck, starboard side amidship. His job was to keep the restroom clean and man the shoeshine stand.

When Fred died, his position was filled by another man. Not long after Fred's passing, a strange thumping came from behind the bulkhead.

The bathroom and shoeshine stand no longer exist, and the *Admiral* itself is slated to close its doors for good. What will happen to Fred?

UNION STATION

In 1946, the movie *Harvey Girls*, starring Judy Garland, brought national attention to the waitresses of the Fred Harvey Restaurant inside the Terminal Hotel, part of the train station in St. Louis. The young ladies had to be of high moral fiber, between the ages of eighteen and twenty and chaperoned by a housemother. They took a vow to remain single for a full year after their employment terminated with the restaurant. The restaurant is now the Station Grille inside the Marriott in the area called the Headhouse, with seating for 130.

Designed by German-born Theodore Link, Union Station was completed in 1894 and was once the largest train terminal in the world. The station was built over a pond that served as a trysting spot, while also being used by many for doing laundry. Suspicions are that this very pond was the source of the cholera epidemic that killed many in St. Louis. Built of Indiana limestone, the terminal fits the bill of drawing possible paranormal activity.

It has a sixty-five-foot barrel-vaulted ceiling in the Grand Hall with the Allegorical Window over the main entryway. The window is hand-made stained glass with hand-cut Tiffany glass featuring three women representing the main U.S. train stations of the 1890s—New York, St. Louis and San Francisco.

The Grand Hall is a Victorian-engineered train shed totaling more than eleven acres with a cost of $6.5 million.

The Headhouse is a mix of Romanesque styles. The station's interior and exterior detail combines Richardsonian Romanesque and French Romanesque or Norman styles. Theodore Link modeled the station after Carcassone, the walled medieval city in south France.

The Midway once serviced more than 100,000 rail passengers a day. At its height the station combined passenger services of twenty-two railroads, the most of any single terminal in the world. The concourse was 610 feet long and 70 feet wide and connected to the train shed, where passengers lined up to board trains through one of the thirty-two boarding gates. The Midway was constructed of a light steel-trussed roof of glass and iron.

In 1903, the station expanded to accommodate visitors to the 1904 World's Fair. Amtrak ceased operations at the station in 1978, and soon it fell into disuse.

Now the station houses a shopping mall and the Marriott Hotel. Charlene Wells worked at a couple of stores within the mall during her two years attending the Patricia Stevens College in St. Louis. During that time she heard fellow employees tell tales of ghosts that had been handed down through the years. "You won't find the stories online but all the employees knew about the ghosts," Charlene says. "Especially the shadow guy who hung our near the Fudge Factory at the time. We always talked about the ghosts when we were on breaks."

The shadow is an unknown, tuxedoed man who roams the corridors at odd times of the day. And then there's George, who kept the keys to the Clock Tower. The tower is 230 feet high and holds the vaults, where thousands of coins were once stored during the heyday of trains and passengers; it also contains the giant valve controlling the station's sprinkler system. Employee

lore says George loved Union Station so much that he still hangs around making noises near the building's offices.

The inevitable lady in white shows up. She keeps to the hotel area, appearing on the balcony overlooking the Grand Hall.

There was Ed Post, who murdered his wife, Julie, in the bathtub of their Union Station hotel room in 1986. Post, a real estate agent from New Orleans, told police he'd gone jogging and returned to find his thirty-nine-year-old wife unconscious in the tub. Investigation into the incident turned up evidence of the husband's attraction to another woman and the increase in his wife's life insurance before her death. Suspicions were raised by the calm, pleasant demeanor the husband displayed following his wife's death plus bruises found on her head, leading authorities to believe she'd been held underwater.

The medical examiner wouldn't declare Julie's death a homicide; the jury found Post guilty of first-degree murder after only a day of deliberation. He was sentenced to life imprisonment. However, a year later, a sheriff's deputy admitted that the sequestered jury had held a party with a police detective present and that another deputy had sex with one of the jurors. The sentence was reversed, and Post was granted another trial. This time, his oldest daughter talked about her parents fighting and drinking.

The second jury found him guilty, sentencing him to life without parole. This was later reversed, and Post pleaded guilty of second-degree murder, claiming he was on weight-loss drugs and had not been himself. His release date is scheduled for 2014; he will have served twenty-five years and be seventy years of age.

Charlene, a member of Route 66 PAL, and my daughter stood with me in the Grand Hall. Near the entrance is the Whispering Arch with a secret. If you stand against the marble wall and whisper, your voice will be heard on the other side, forty feet away. Upstairs we gazed down on the spot where passengers mingled—which is where *Escape from New York* was filmed—and ghosts come out to play.

The Caves of St. Louis

Missouri has 6,300 registered caves, some of sandstone and others of limestone and carbonite rock. Missouri's landscape is known as karst, meaning the earth is full of caves, springs, sinkholes and losing streams where the water disappears into a swallow hole and reappears elsewhere. There are

over 3,000 reported springs in the state. Greene County, where Route 66 was conceived in Springfield, lists more than 2,500 sinkholes.

The caves of St. Louis were storage for food and lager beer. Folgelbach Cave served as a water runoff and sewer system. Klausmann's Cave boasted a beer garden and held concerts and carnivals. On the future site of Union Station, a cave existed beneath Chouteau's Pond—the water hole blamed for the cholera outbreak. During the widening of Market Street, the cave showed remains of the Winkelmeyer brewery and mushroom beds.

Uhrig's Brewery expanded its cave with brick walls, arched ceilings and a narrow-gauge railroad to transport its beer between brewery and the cave. It was a spot for the people of St. Louis to gather for glasses of beer and listen to music. The cave became military headquarters during the Civil War. It was used as an opera house, roller rink, bowling alley, mushroom farm and an arena for sporting events and revivals. The world's largest indoor swimming pool existed here. Many notable events took place, including the Veiled Prophet Ball that later gave way to the Fourth of July Spirit of St. Louis event.

Anheuser–Busch utilized a cave, building a small brewery on the ground above. Most breweries came into being in St. Louis because of the presence of the caves.

Cherokee Cave is the site of the Lemp Brewery; it also held beer from the Minnehaha Brewery. Adam Lemp first used the caves. Stone arches and brick ceilings were installed to prevent water seepage. The cave floors were paved, staircases and walkways placed and large kegs built to hold the beer. During the Civil War, the military stored munitions in the caves.

The Lemp Brewery had a tunnel leading from Cherokee Cave to the brewery and mansion, an underground theater and ballroom where Lemp entertained his guests. After refrigeration became available, the cave was used mainly as a playground. It had a pool, ballroom and theater. Although the entrances were closed after Prohibition, the rooms below are said to still be intact today.

The Minnehaha side of the cave was developed as a tourist attraction and also dubbed Cherokee Cave; during the work, bones of extinct animals were located.

Lee Hess, owner at the time, developed a strange obsession for the cave, nearly losing his fortune on its development. The cave was closed in 1960, partially destroyed to make way for Interstate 55. Spelunkers declare portions of the cave exist today. On the Lemp side, rumors of accessibility and strange sounds and shapes persist. During a haunted house sponsored by the Lemp

Ghosts along the Mother Road

Vintage postcard of Benton Park, St. Louis. *Courtesy of Janice Tremeear.*

Restaurant, an unknown person was spotted in an unauthorized section of the cave. Workers attempted to track the intruder down, finding no one.

Other caves beneath St. Louis became gambling halls and hosted criminal activities.

Ezra English owned a brewery, setting it up inside a cave named after him located east of Benton Park and first used by Native Americans.

English Cave is the stuff of legends. Bad luck and misfortune shadowed those unlucky enough to own it.

The tale unfolds of a young Indian woman who fell in love with a man of her village. She was already promised to the tribe's war chief, a rather disagreeable man, and the couple was unable to marry. Deciding to run away together, they took shelter in the cave. The war chief and his men took up stations outside the cave to capture the couple when they emerged, but the two remained in the cave until they starved to death.

Explorers who heard the story of the young couple discovered bones of two people deep within the cave years later. Stories of crying and weeping have been reported and voices speaking in another dialect.

The cave seems to be cursed; English suffered from his ownership of the property. He made little improvements on the cave but stored his brew there, offering it as a place for customers to get a drink. He took a partner by the name of Issac McHose, and they expanded the cave into a beer garden and resort. Next door to the newly named St. Louis Brewery was a graveyard

built for the victims of the cholera epidemic. Attractions were added to bring visitors into the newly dubbed Mammoth Cave. In the year of 1849, the great fire destroyed the riverfront of St. Louis and the epidemic took many lives. No one was in the mood for entertainment, and English lost his business partner and, soon, his business.

The bodies from the nearby graveyard were exhumed and taken to another site south of Jefferson Barracks, and the cave itself was forgotten. In 1887, the cave was turned into a mushroom farm, but that enterprise folded in two years. Other endeavors included a winery and plans to make the cave an attraction of Benton Park; both failed.

The ground beneath the park is littered with cavern rooms and tunnels, but no one can find an entrance, even though many leads were followed to find one of the openings.

A pond in Benton Park emptied into the cave below, and a concrete bottom added to the pond still cannot prevent water seeping below ground. The cave is reported to be flooded and inaccessible. All attempts to keep the cave open to the public in some manner have failed. Maybe the young Indian couple wants to keep their privacy.

Benton Park hosts a haunted bed and breakfast located in Lafayette Square. Edward Rowse Sr., for whom the home was built by Frederick and Nora Lehmann in 1893, haunts the Lehmann House.

Oddly enough, Rowse died within a year of the completion of his home, as did the architect and construction foreman. Rowse died in his room, and the activity soon followed. Footsteps, the sound of wagon wheels inside the house and something crashing to the floor in a locked third-floor room have been reported. A man and woman dressed in period clothing have been seen standing in the room where Rowse died. Dogs refuse to enter certain areas of the house, and objects appear randomly.

Is the honeycombed ground beneath St. Louis responsible for the ghosts of Benton Park?

Chase Park Plaza Hotel

For years the Chase held the story of the Red-Haired Woman seen at the hotel. She was said to haunt room 304. Then the stories were said to be not of a ghost but a mysterious female visitor seen on her visits to an executive of the hotel by entering an adjoining room.

Now the stories have changed: the Red-Haired Woman ghost is real, and she wears the mandatory uniform of all female ghosts, the white dress. She is seen on the third floor of the eleven-story building. The reason of the white dress is simple—she threw herself out of the window to her death on her wedding night on the 1930s.

Chase Park Plaza was built in 1922 of red brick, one of the factors in harboring ghosts—if the television is to be believed. The hotel and its twenty-nine-story neighbor feature a two-story lobby designed to replicate the Savoy in New York City. The two hotels combined offered nearly sixteen hundred rooms during the 1930s and '40s, and the Park Plaza was listed practically perfect as a hotel. The economic decline turned the Park Plaza into apartments. In 1956, the hotels merged with the lobbies connecting the hotels and the Khorassan Room, becoming a feature of both.

A second ghost haunts the building, believed to be Chase Ulman, the hotel's namesake. This tuxedoed ghost is also considered the very same ghost haunting the Opera House on the location of the Frankie and Johnny shooting that inspired the popular song. Chase Ulman died nearby at the Chester Apartments. He is seen looking out of windows and walking inches above the floor. He is quite well heeled in appearance.

Soulard Market

Soulard Market is the largest continuous farmers' market west of the Mississippi. Established in 1779, Antoine Soulard's widow donated two blocks of property to the city for a public market. Antoine had been the surveyor general of Upper Louisiana and a refugee from the French War. The Spanish governor gave him land in what is now part of St. Louis in payment for his services. Showplace homes were built in the style of Greek revival. Following the Civil War, such people as Max Feuerbacher, Julia Soulard, Adam Lemp and Eberhard Anheuser built many large mansions. The market building was first erected in the 1840s and then enlarged in 1865.

The tornado of 1896 destroyed the market plus many surrounding buildings. In 1929, it was rebuilt in an Italian Renaissance style inspired by the Florentine Hospital.

Commercial business flourished, and one of the first horse-car lines was established to run from Caradolet Avenue to Russell, Twelfth and Gravois, carrying merchants and business traffic.

After World War II, the marketplace fell into disrepair. A returning interest in the 1970s sparked a renewal in Soulard to rebuild its unique architecture.

The Lion House was built of brick and stone and the first home in St. Louis, with stone lions guarding the entrance to the drive. Max Feuerbacher, owner of the Green Tree Brewery, built the house on Sydney Street (some spellings show Sidney) and State (now Twelfth), which resembles a castle. With twin bay windows, a large pipe organ, plasterwork, the first burglary system in a residence, a frescoed ceiling, triple-entry doors, chandeliers, a cupola, cellars for lagering beer and an entrance to Cherokee Cave, the mansion was a St. Louis showpiece for one of the landed gentry citizens of the city.

The Lion House shares a feature with many of the haunted locations previously mentioned: in the sub-basement, there allegedly is an entrance to Cherokee Cave. Present inhabitants of the house report the figure of a man, blasts of cold air, flushing of the toilet and toys being rearranged. Thumping sounds are heard, but when the sound is tracked, no one is there. The doorbell rings and no one is there. Footsteps are heard.

Soulard in St. Louis is home to one of the best Mardi Gras celebrations in the nation; the spirits take to the festivities as well. Reports of private residences with ghostly occurrences pop up in the area.

Feraro's Jersey Style Pizza has its share of entities. Apparitions are seen on the patio and in the bathrooms, objects fly about and bottles explode. Feelings of being watched, white masses and a cold breeze flowing through the building are reported.

The pizzeria is thought to have been a carriage house in a former life. Now people see figures that include one full-bodied apparition of a little girl. Air moves past people; hair is tugged; the open–close sign flips opposite of what it should be; and knocks are heard on furniture.

Part of Soulard was destroyed by the F4 tornado of May 27, 1896. Eighty-mile-per-hour winds tore into Layfayette Park. Most of the damaged area is long gone, replaced by I-55. Could the spirits in Feraro's be victims of the third-worst tornado in American history? The haunting may be connected more with the land—the area—than simply one building.

Laclede's Landing

Charlene tells me of visits to Laclede's Landing—known simply as the Landing—and stories of riverfront haunts. The cyclone damaged Eads Bridge, and the Landing sits between Eads and Dr. Martin Luther King Bridge.

Tammy Preston agrees that there are ghosts along the Mississippi. Tammy and Charlene brought me this report of a drunken boat captain running his boat aground on the St. Louis side of the Mississippi.

> *They were aground near a bend in the river, which prevented them seeing the St. Louis City lights. The lights they saw were across the river belonging to East St. Louis, Illinois.*
>
> *The captain told the passengers to swim for the lights not knowing they were too far to reach them. It was in the middle of winter and the river was freezing; most drowned before reaching shore. The passengers now haunt the St. Louis, Missouri side of the river at Laclede's Landing, the point of their destination.*
>
> *Sightings include people coming out of the river soaking wet and men looking for the captain of the riverboat, angry over the accident. It's thought the men are looking to lynch the captain over the accident.*

Many boats sank during the tornado strike in 1896, according to the report in the May 28, 1896 edition of the *Daily Republican* in Decatur, Illinois. A long list describes damage brought by the cloud demon that struck at 3:00 p.m. Over sixty-three deaths of passengers and crew on boats in the river are given. A location with a history of violence can give birth to the presence of ghosts and then becomes what is known as stigmatized. Private homes known to be haunted were once required to be listed as such to warn potential buyers. With the tragedies of the riverfront, Laclede's Landing may be stigmatized property.

LEMP MANSION

Surely one of the most infamous haunted locations in St. Louis is the Lemp Mansion. In 1838, Johann Adam Lemp left Eschwege, Germany, joining thousands of immigrants coming into St. Louis. He started building the Lemp fortune by opening a grocery store. Vinegar became his most popular-selling items, and his brewery made his own supply. Lager beer naturally fit in with his plans. Lemp learned the art of brewing from his father in Germany, and the cold caves beneath the city proved useful. Lemp's beer was different than the dark English ales currently popular. In 1840, he relinquished the store, devoting his time to brewing. Ice was chopped from the river and taken to the cave to further keep the beer under perfect conditions.

Adam Lemp was a millionaire by his death on August 25, 1862. Approximately forty breweries dotted the city when his son, William J. Lemp,

took over. By 1870, the Lemp brewery was the largest in St. Louis. Falstaff beer was produced, and the brew gained national attention in the 1890s. Today, another company brews Falstaff products after purchasing the name from the Lemp family. William Sr.'s daughter, Hilda, married into another well-known St. Louis brewing family when she took Gustav Pabst as husband.

William Jr.'s wife, Lillian, was considered by some to be a trophy wife. She was known as the Lavender Lady for her penchant of dressing in the color and going so far as dyeing the harness of her carriage horse lavender. Lillian was beautiful, but William was not a faithful husband.

One of the reported spirits of the mansion is Zeke the Monkey Face Boy, seen peering out of the attic windows. The boy is said to be William's illegitimate son, born from one of William's prostitutes who had Down syndrome and was confined to the upper region of the home. Although many claim to have seen the boy, there are no records found on him. It's possible during William's time a child born out of wedlock to a man of standing and wealth in the community would be kept hidden. To have a child known to be Mongoloid, as the past term was used, could make the situation intolerable for the Lemps. It is believed the boy died in the 1940s and was buried in the Lemp cemetery with a small marker noting his resting place. Another legend concerning the boy is that he was William's brother, born when William's mother, Julie, was close to fifty and that the child was deformed and possibly mentally retarded because of her advanced age. Some sources say Zeke died at sixteen; others say he was age thirty.

William Sr.'s son Frederick, named for his friend Frederick Pabst, died from heart failure when he was only twenty-eight. The young man's illness took its toll in 1901 and left his parents shattered. Frederick's death changed William Lemp forever.

Then in 1904, Pabst died. William Sr. became more disinterested in running his business, and his health started to decline. At the age of sixty-seven, one month after Frederick died, William mentioned after breakfast that he wasn't feeling well. He went upstairs to his bedroom and shot himself with a .38-caliber Smith & Wesson revolver. His death brought hard times for the brewing company as the city of St. Louis was preparing for the Louisiana Purchase Exposition, the 1904 World's Fair.

William Lemp was only one of the prominent St. Louis German-Americans who committed suicide. Corrupting the word *deutsch*, which means German, the police coined the slang term "Dutch Act" in reference to the many instances of people taking their own lives. Besides the suicides of the Lemp family, other men whose fortunes were affected by Prohibition

killed themselves: Patrick Nolan of Mutual Brewing Co., Otto Stifel of Union Brewery and August A. Busch.

Elsa Lemp-Wright was the youngest daughter of William Lemp Sr. She was the richest heiress in St. Louis. Her fortune increased when she married Theodore Wright of the More-Jones Brass and Metal Co. The marriage was not a happy one, and Elsa filed for divorce in 1919. Her divorce was granted within an hour after filing and kept quiet. Then, in 1920, Elsa and her ex-husband reconciled and later remarried. Elsa suffered from indigestion, nausea, severe depression and insomnia from stomach pains.

On the morning of March 19, 1920, she told her husband she was doing better after a sleepless night. She wanted to remain in bed, and Wright went into the bathroom to draw a bath. He heard a sharp sound over the noise of the running water and opened the bathroom door to call to his wife. Elsa didn't answer. Wright found her on the bed staring at him. When he got closer, he saw the revolver lying next to her. Elsa tried to speak to him but failed. In moments she was dead. There was no note or any indication that Elsa was considering suicide. The authorities were not notified about Elsa's death for over two hours. There has been speculation foul play was involved in Elsa's death.

William Lemp Jr. filed for divorce in 1908. His wife, Lillian, was a frivolous shopper and had been put on a daily allowance. William claimed Lillian had been seen smoking and drinking, and, of course, she brought out Billy's amorous activities. William lost custody of their only child, William Lemp III. The divorce was quite vicious and notorious in St. Louis; William was even accused of being cruel to animals, staging fights in the caves. He was said to carry a gun and was likely to show or point it at anyone, and he kept it beneath his pillow, aimed at Lillian.

Prohibition damaged breweries attempting to remain afloat by making "near beer," but the Lemps were individually wealthy and overlooked any need to keep the brewery afloat. William let the company go—one day locking the brewery, letting no one inside. He sold the Falstaff trademark to Joe Gresedieck for $25,000.

On June 28, 1922, the Lemp Brewery was sold at auction. The plant had once been valued at $7 million and covered ten city blocks. International Shoe Co. bought it for $588,500.

William Jr. became nervous and erratic after selling off the last of his father and grandfather's legacy. He became reclusive, complained of headaches and his health failed.

On December 29, 1922, William Jr. spoke with his second wife, Ellie, on the phone, sent his secretary downstairs, unbuttoned his vest and shot himself in the heart with a .38 revolver.

He was breathing when found but died before the doctor arrived. As with his father and sister, there was no suicide note. William was interred at Bellefontaine Cemetery near his sister.

Prohibition was repealed in 1933; Falstaff Brewing was ready to supply the citizens of St. Louis with beer again. One of the few companies left with the means to brew near beer, Falstaff took over Union Brewery. Falstaff beer expanded nationally. But for the Lemps, troubles continued. William Lemp III suffered misfortunes, which affected his marriage. He and his wife, Agnes, separated and divorced a short time after losing his father's property in Webster Groves. William III's attempt to bring the Lemp family back into the brewing business failed. William passed away in 1943.

Surviving brothers Charles and Edwin were the remaining members of the immediate family. Charles remained a bachelor, becoming a recluse after moving back into the Lemp Mansion. He became odder with age, following the path of his brother and father. Arthritic and ill and reported to be afraid of germs, he wore gloves at all times. His attachment to the home and his fear of germs grew to morbid heights. Refusing to move out of the mansion, he slid further into insanity. He lived there with only two servants; Zeke, the Monkey Face Boy; and his Doberman pinscher, Serva.

On May 10, 1949, a staff member prepared Lemp's breakfast and left it on the desk next to Charles's office. By 8:00 a.m., the tray had not been touched. When the servant, Alfred Bittner, opened the door to check on Charles, he found him dead from a bullet to the head. The Doberman was found dead on the stairs after Charles had shot the dog in the basement to prevent it from attacking anyone who came to the house once he was gone. The dog dragged itself up the stairs until it collapsed. Charles broke the family trend and left a suicide note saying no one was to blame but him. He left orders that he not be prepared for burial. His body was taken out to his farm; however, no one seems to know the farm's location.

Edwin Lemp survived the curse that stalked his family but secluded himself on his property in Kirkwood, Missouri, a suburb of St. Louis. Edwin died of natural causes at age ninety, ending the Lemp empire.

Rumors have it the Lemps maintained a zoo in one of their buildings. There is also the legend that money is hidden somewhere in the mansion. The noises are thought to be of the Down syndrome child kept in the attic.

Ghosts along the Mother Road

The mansion is thought to be one of the most haunted locations in America, according to *Life* magazine. People report knocking, footsteps and horses neighing and dogs barking; bells ringing, doors slamming and cold spots permeate the house; a piano plays in an empty room; water swirls by itself in a pitcher; and in the restaurant sections of the mansion, glasses lift into the air. Apparitions appear and disappear in front of witnesses; drawers slide shut on their own; and doors lock and unlock on their own. Toys move in the attic; people see the Monkey Face Boy looking out from the windows onto the street below; and candles light by themselves. A man in a dark suit has been seen sitting at the dining room table. The waitress asked him if he wanted a cup of coffee, but he didn't answer. When she returned her attention to him a moment later, he was gone.

Some people experience feelings of being watched, of fear, dread and even an evil presence. A popular story is one of a carpet layer who heard the sound of dog's claws coming up the staircase and the odor of the animal's breath near him. Women in one of the downstairs bathrooms feel someone is watching them over the top of the stall.

The Lavender Lady, Lillian Lemp, is thought to wander the mansion. The basement leading to the Lemp Cave appears to have a lot of activity and is called the Gates to Hell.

A well-dressed man in highly polished shoes is seen. Horses are heard trotting over cobblestones, and during the renovation a patch of dead grass was noticed. Cobblestones were found beneath the grass.

Ghost tours are given at the two-hundred-year-old mansion. Tales are recounted about the Lemp family, the suicides and of the little girl named Sarah who lived in the house after Charles's death when it was turned into a boardinghouse. The tour guide says little Sarah was murdered and Charles's ghost witnessed the act. Another ghost is a former caretaker who wanders the halls. Animals other than Serva are thought to haunt the home. A smaller dog is heard yapping, and there are cats, too. People not associated with the Lemp family are seen during the day. They disappear as soon as they are noticed.

Charles is said to appear to visitors who stay the night in what was once his bedroom, bursting into the room and glaring at the intruders.

Guests sleeping there in William's room hear running up the staircase and kicking on the door. This is guessed to be when Billy Lemp ran up to the room to find William Sr.

Julie Lemp also haunts the mansion. She died of cancer in the room next to William Sr.'s. Julie roams the house unaware of anyone but searches for her sons and perhaps for Zeke.

Elsa Lemp's room is the most haunted, it is said. Elsa did not die at the mansion, so who is haunting her room? Shadows are seen moving there—perhaps Elsa has come home.

The mansion was nearly lost by the construction of I-55. Luckily the house was spared and sits across from Anheuser-Busch Brewery, perched above the highway.

The Booth Brothers's film *Soul Catcher* was filmed partly on location at the Lemp Mansion. They took Native American psychics with them inside the home. A mist formed above the head of one of the psychics, taking on the shape of a face with a bag or mask over its head.

I've stared up into the windows of the home and felt transported from the bustle of the freeway into another time, one filled with the sadness of a family who once had it all and saw everything slip away from them.

Hitchhike Annie

Calvary Cemetery and Bellefontaine Cemetery

The cholera epidemic of 1849 was not the only outbreak of disease to hit St. Louis. The Committee of Public Health report of July 19, 1849, stated six thousand people were buried in a little over one hundred days. On August 24, 1866, another sweep of cholera struck the city, and cemeteries were again overflowing. In 1879, an ordinance was passed to regulate cemeteries. It did not allow any new cemeteries or any expansion without expressed permission of the city nor was it lawful to bury the deceased anywhere but a designated cemetery.

Anyone burying the dead without a permit from the health commissioner would face a fine of $100. Cemeteries could not accept a body or bury one without a permit, and the sites faced fines of $250 to $500 for each day the body was interred without the permit.

Many have been moved or the names changed; Bellefontaine was once called Rural Cemetery.

Bellefontaine and Calvary Cemeteries are two of the most beautiful and largest cemeteries in the Midwest. I wandered through them as a child with my parents. My love of cemetery art was born here. Tombstones and structures loomed over me, and I was fascinated by the carvings and monuments. Now, if possible, when our team goes on paranormal investigations we search for a graveyard. We take cameras and digital recorders along. You never know where ghosts may linger.

Ghosts along the Mother Road

Some say cemeteries aren't haunted—that the spirit would reside in whatever location the person died. Others think the graveyards can and are haunted and that, for whatever reason, the spirit stays in the location their body was buried. I carry with me the book *Stories in Stone*, a field guide that is compact and easy to pack around on the symbolism and meaning of the icons in cemetery art.

It is a history lesson in itself to discover the meaning behind the carvings and adornments on the tombstones. Maybe this was one of the beginnings of my interest in the paranormal since cemeteries are mysterious, often spooky and to many a frightening place. Or perhaps I just have a macabre sense of beauty coupled with a drive to go ghosting, to question and confront what most people are afraid to face.

As cemeteries developed, the higher-class citizens were buried to the east as close to the church as possible. Social standing exists even in death. As in the case of the *Titanic*, those of wealth and social stature were given the "best seats in the house," placed with the first view of the rising sun and among the first to rise on Judgment Day. Lower-class citizens were buried to the south. The north corner was considered the Devil's Domain.

The north end of the cemetery held suicides—if those poor souls were buried on sacred ground at all. The north end held stillborn children, bastards and unknown people who may have died while in the town.

Suicide burials were handled differently than a regular death; the body was carried over the top of the wall, not brought in through the front gate of the cemetery.

Bellefontaine came about during the epidemic, and nearby Calvary gave even more space for the burial of St. Louis's dead. During the height of the epidemic, it was reported that there were thirty burials a day, and the city declared those victims were to be interred outside the city limits. Bellefontaine grew to handle the bodies. It is the final resting place of Thomas Hart Benton, General William Clark, Sara Teasdale, William S. Burroughs and, of course, the infamous Lemp family.

Calvary Cemetery is a beautiful example of the garden cemetery, utilizing the wooded settings and rolling hills as does its neighbor Bellefontaine. Situated across Bellefontaine on Calvary Drive, it too was used for the burial of cholera victims and was located six miles outside of the city at the time.

Notables resting there include Dred Scott, William Tecumseh Sherman, Dr. Thomas A. Dooley, Kate Chopin and Tennessee Williams.

Father William Bowdern is buried at Calvary. He allegedly participated in the exorcism of a demon from a boy from Washington, D.C.-area who

came to St. Louis. The boy was at Old Alexian Brothers Hospital during his affliction.

The hospital is now torn down; a parking lot was paved over the site. A large crack exists in the pavement where the boy's room was—and the crack cannot be repaired. The boy's story of possession was the inspiration for William Blatty's *The Exorcist*. The Booth Brothers have filmed a documentary on the possession, called *The Haunted Boy: The Secret Diary of the Exorcist*, based on one of the copies of the dairy of Reverend Raymond Bishop, who was involved with the exorcism. The diary contains notes from the other priests and was hidden in a sealed room.

The artwork is amazing in both cemeteries. Towering over me as a child were the angels, shrouded and veiled women, life-sized carvings of the dead and mausoleums lining walkways like a mini, replicated city.

Calvary Cemetery has a tale of a statue that watches you. Set back into the cemetery about 150 feet from the iron fence is a headstone with an angel draped over the marker.

Early depictions of angels on sarcophagi portray them as solemn young men. Since they are considered to be messengers, they were given wings in the Middle Ages. Halos, white garments, swords, harps and horns became part of the angel's physical makeup during the Renaissance. Angels are portrayed as heroic and glowing with a beautiful countenance. Smaller angelic beings are the Putti (Cupid), lighthearted angels often attached to children's graves.

The angel in Calvary seems to be grieving at the grave. Her face is hidden from sight, buried in her arms.

There is an urban legend connected with this angel. She has been reported to raise her head and stare at you, making eye contact with you. She motions to you briefly before laying her face back onto her arms.

Hitchhike Annie is another urban legend connected to the road between the cemeteries. There are three different versions of the story, but all tell of a hitchhiker on the gloomy stretch connecting West Florissant Road and Broadway. Dating back to the time when automobiles were making a mark on road travel in the 1940s is the tale of a young woman spotted early in the evening, just as the sun was setting. Soldiers returning from the war gave her the name Hitchhike Annie. She is always described as pretty with dark brown hair, a white complexion and wearing a white dress, which seems to be the standard uniform of ghostly female sightings. She's been seen by hundreds of people over the years.

Drivers stop to lend her a hand or she waves cars down to catch a ride. Annie can be spotted on different roads, but it's always the same story: car trouble and she needs a ride. Annie disappears from within the car and always at the entrance to Bellefontaine Cemetery.

Or there is the tale of a boy dressed in old-fashioned clothing who appears in the middle of Calvary Drive, causing cars to swerve to avoid him. He vanishes when drivers try to look for him. Another female ghost—dressed in a black mourning dress this time—crosses the road, appearing suddenly in the street. She wears the long dress with a hat and veil covering her face. As drivers brake to a stop she disappears.

Is there a connection between this stretch of road and the graveyards? Is the epidemic the cause of the unrest for the dead in this area?

THE FEASTING FOX

Once a inn owned by Anheuser–Busch in 1913, the Feasting Fox was first known as the Busch Inn belonging to August A. Busch Sr., founder of Busch Brewery and one of the prominent German citizens of St. Louis to commit suicide over Prohibition. He wanted to prove beer could be served at a family restaurant and elevated the idea of beer drinking out of saloons with sawdust floors. The inn is now a restaurant with a German theme. Anna Busch is said to have hung herself upstairs in what is now the banquet room due to unrequited love, and now her ghost haunts the dining establishment.

FOREST PARK

Art Museum

Forest Park is west of Route 66 on Highway 40 and another short side trip from the Mother Road. The park sits on 1,371 acres of land, 500 acres larger than Central Park in New York City. Built in 1876, the western end of the park became the site for the 1904 Louisiana Purchase Exposition that drew 19 million visitors and is otherwise known as the St. Louis World's Fair. Called the Crown Jewel of St. Louis, the park has 7.5 miles of biking, jogging and skating paths. It is a golf mecca, with lakes and a skating rink.

Forest Park, St. Louis. *Courtesy of Charleen Pestana.*

A few World's Fair buildings still stand. The art-deco style Jewel Box, the walk-through Bird Cage in the St. Louis Zoo and the Art Museum are still standing and visited by people today. Another feature within Forest Park is the Muny Theater, built from a natural amphitheater near Art Hill.

I spent many summer evenings in the free seats, armed with binoculars and munchies Mom and Dad packed while we watched musicals during the theater's outdoor season.

The zoo is one of the few free zoos in the nation. When I was a kid, Phil the gorilla was a big attraction. My family still brings up my aversion to Phil splashing water at us from his cage. They just didn't understand my aversion for gorilla water splashing over my snow cone.

The park still attracts visitors; some say the Art Museum is haunted, with ghosts hanging around to view more than the exhibits.

An electric feeling is felt on one of the steps leading down to the Arms and Armor section. A Polynesian medicine man's head is on display and tries to escape the museum. Scratch marks are rumored to be on the inside of the display case glass.

A watchman still conducts his nightly tour of the museum in his out-of-date uniform. He'll wave at you but never speaks.

Old Courthouse

French traders founded the Gateway City in 1764 on land originally occupied by people who built mound dwellings. St. Louis earned the nickname Mound City because of these former inhabitants. Not much is known of what happened to these early peoples, but the location at the Missouri and Mississippi Rivers was ideal as a port. Lewis and Clark departed from St. Louis in 1804 on their trek west, and its location was a prime draw for immigrants seeking to build a home.

The Civil War didn't touch St. Louis the way it did areas farther west and south along what became Route 66, but facilities such as the Gratiot Street Military Prison soon held prisoners of war, spies and civilians suspected of treason. Operated by the Union, the prison held even Federal soldiers suspected of disloyalty.

Bad food, terrible sanitary procedures, contaminated water and overcrowding led to many deaths. Smallpox broke out, and in a system built to house twelve hundred people maximum the pox had plenty of ways to spread. At times upward of two thousand prisoners were reported in the jails.

St. Louis's slave trade was a market held at the courthouse. Before the Civil War, steps to the courthouse contained hooks where men and women remained chained, waiting to be sold. Reported cries of the slaves echo through the building. Lights turn on and off, and doors move on their own. The St. Louis police have been called to investigate frightening noises, only to find the building empty.

Dred Scott is known as the slave who sued for his freedom in the St. Louis courts. After eleven years the U.S. Supreme Court decided Scott would remain a slave. In the end, Dred Scott died of tuberculosis. He was freed a year earlier. His body was moved to an unmarked grave in Calvary Cemetery. A marker was placed on his grave in 1957. The marker gave the date of Scott's birth and death and said he was the subject of the decision from the U.S. Supreme Court to deny citizenship to the Negro, voiding the Missouri Compromise Act and being one of the events that led to the Civil War.

Of interest, and perhaps the cause of the haunted activity in the courthouse, are the stones making up an exhibit in the building. A large stone warehouse was erected on Main and Chestnut Streets in 1818, the property of fur trader Manuel Lisa. His business became known as the Old Rock House, which not only stored furs but also supplies for the military.

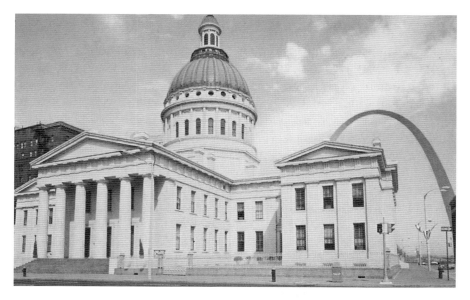

Vintage postcard of the old courthouse and St. Louis arch. *Courtesy Janice of Tremeear.*

"Black Manuel" was bold, aggressive and fearless; he was also generous, brilliant and fair in his business dealings. Lisa was killed in a brawl in 1820, and the storehouse was taken over by another fur trading company. A new roof was added, and it was turned into a saloon with a nightclub on the second floor; rooms on the third floor were used as a bordello.

The Old Rock House was dismantled in 1939 and restored. It was taken down again for railroad tracks and the Gateway Arch; the stairs leading to the arch occupy the space where the former warehouse once stood. Stones from the Old Rock House became part of the exhibit in the northwest corner of the old courthouse. If spirits occupy not only a space but also objects, then perhaps the souls associated with the warehouse and bordello have stayed with the stones of the building and now occupy the courthouse.

ZOMBIE ROAD

One of the sites most often mentioned as haunted in the St. Louis area is Zombie Road. It dead-ends at the River of Death, as the Meramec River was called due to the accidents in the waters. The name has been around for nearly 60 years, and the road has been in existence for about 150.

Ghosts along the Mother Road

I heard that name as a kid, spoken in secretive whispers. There were dares and invites similar to "Have you ever been on a Snipe Hunt?" among the teens.

Zombie Road was a place you did not go to alone. Bad things happened there. Bad things had always happened there. It was a site for witches and devil worship with signs of rituals being carried out on animals.

Old-time music is heard, and moving lights float about and follow you. Ghosts of gangsters who died in the speakeasies still linger. Children drowned in the river gather on hillsides, lonely and lost. It's an old road existing since 1866. Some theorize the old horse-and-buggy road may have existed as an Indian footpath since it's one of the few areas accessible along the Meramec River bluffs. The Indians may also have quarried flint for their weapons here.

The road is located in Wildwood, in what was formerly known as Ellisville and Glencoe. Officially the road is Lawler Road but was named after a mental patient, nicknamed Zombie, from an institution that was supposed to exist there. He wandered away one night and never came back, his bloodied nightgown found by the side of the road. Zombie is also alleged to leave the asylum, stalk and kill partygoers on the road and return to the institution before dawn. One version says the mental patient was killed in the asylum after murdering twenty-two people.

Hallucinogenic drugs, teens and zombie movies might explain the road's name.

After my family moved away from St. Louis to a farm about an hour's drive west off I-70, I still heard tales of the road. Apparently everyone from mid-Missouri to the eastern edge of the state knew of Zombie Road at one time. As a teen, my classmates chattered about Zombie Road—two miles of forested hills and dead ends made up the landscape. Weekend snooping might result in being chased by man-sized shadows or white apparitions appearing as lumps next to them, rising up and assuming a woman's form.

A hangout for druggies, it had the inevitable "killer with a hook" of campfire fame.

It was remote and inviting for bored teenagers. A trip into the city to party in an out-of-the-way, creepy spot where cops wouldn't mess with you was extremely inviting. Once the police chained off the road, it was a bigger challenge for teens to sneak past authority.

The road was constructed to haul limestone and marble to the Glencoe Marble Company. Strange sounds were heard along the road and no source could be found. It became all but abandoned after the mining company shut down. Weeds overtook the road; tree roots tore up the pavement. An interesting bit of lore is if you travel the two miles one

day and don't return for a day or two, it will appear to be a completely different road. Sounds occur just beyond the pavement; sounds normal woods should not make.

Dilapidated houses and shacks line the area; a legendary old woman resides in a home at the end of the road. She's thought to be a witch and runs out with her gun to chase down passersby.

The road is where Old State Road meets Highway 109 near a regular railroad track with the reputation of deaths caused by the trains. A mini train ride for kids exists there now. But a 1970s story says a train struck two teens, and body parts of the unfortunate youths were scattered about the area. A mother and her five-year-old were crossing the bridge in the 1990s when an approaching train trapped them. The mother pushed her child off the bridge in a panic. The train engineer was able to stop the train and rescue the child, but the mother perished. One ghost haunting the area is a man who was struck by the train in the 1970.

There's the story of a teen who died on the road from huffing, or sniffing, the spray can product Pam.

Another teen on the bluffs lost his footing, slipped and caught his face on a tree growing from the side of the cliff. His face and scalp remained, while he fell to his death below. This may be the same boy who died during rock climbing. He fell from the cliff, breaking his neck; his friends ran off and left his body there for days.

A crushed Chevy Vega was said to be in the creek near the area with two or more dead teens inside. A hose that ran into the interior of the car blocked the exhaust pipe. Some stories say only one person was inside the vehicle and that a hunter found the car.

A pioneer who lost his wife in a poker game haunts the road after taking his own life in his home.

Native Americans are also on the list of the ghosts that frequent Zombie Road.

A ferry was operated at the bottom of the river passage in the 1800s at a ford for settlers and travelers crossing the Meramec. On the opposite side of the river, the Lewis family owned land. How the road came to its original name of Lawler Road is unknown today.

The first to settle was Ninian Hamilton in 1803. James E. Yeatman of St. Louis, founder of Mercantile Library and president of the Merchants Bank, came into possession of Hamilton's land after his death in 1856.

The Pacific Railroad built its line from St. Louis to the Pacific Ocean along the Meramec River in the 1850s. Della Hamilton married Henry

McCullough, justice of the peace and county court judge from 1849 to 1852. She was struck by a train and killed in 1876.

In 2007, Spooked Productions released a documentary filmed by the Booth Brothers called *Children of the Grave*; portions of the movie were shot on Zombie Road. Photos of shadow people dot the woods, and one image shows a large, solid-looking shadow blocking the road at a bridge trestle.

The area became Yeatman junction; the first large-scale gravel operations began here. In the 1850s, gravel was hauled from the river and taken to St. Louis by rail. Steam dredges were employed later and then gasoline-powered machines in the 1970s, removing gravel from the river channel and digging artificial lakes at the riverbanks.

Winston Churchill, an American author at the turn of the century who wrote romantic novels, visited the area in the late 1800s. His novel *The Crisis* is set in St. Louis and the Glencoe area. The novel is based on the life of James E. Yeatman, with his daughter Angelica being the model for his heroine. The book takes places during the years of the Civil War in St. Louis.

Glencoe was a resort area from the 1900s to about 1945. Many homes were summer houses, and clubhouse communities existed along the Meramec. The homes converted to year-round dwellings and were lost to flooding in the 1990s.

Apparitions are reported from both recent history and dating back to the building of the road, some from the time of the Cahokia Mound builders. These ghostly tales are those that lend to Zombie Road being the portal between worlds.

A man is said to have been driving down the road and saw a strange person walking behind his truck but with incredible speed. As the driver accelerated so did the figure. Eventually his vehicle outran the smoky apparition, but he refused to return to that stretch of road.

A not-so-otherworldly tale is the sightings of black panthers by hunters. The large cats were not common in the area.

Lawler Road is being turned into a bike trail from Ridge Road to Foster Trail. What change will this bring for the ghosts of Zombie Road?

Shaw's Garden

The Missouri Botanical Garden is also known as Shaw's Garden. It is one of the last original Victorian walking gardens in the world. Henry Shaw began the garden in 1857. Born in Sheffield, England, on July 24, 1800, he

displayed a love for gardens and plants at an early age. Henry and his father started an ironwork manufacturing business, and when it began to fail they made the trip across the ocean to America.

Arriving in America he made his way to St. Louis, which at the time stretched for only a mile along the river and was a mere three blocks deep. The city was young, only fifty years old, and looked much as it did when founded by Pierre Laclede.

Henry built a new business in town selling hardware, tools and cutlery. Soon he was importing goods from England. After making a profit of $25,000, Henry decided to sell his business.

In 1819, he first saw the land he would convert into his magnificent garden. The area was remote from St. Louis—a vast, wild prairie covered in undulating grass. Henry had visited the Royal Botanic Garden in Kew, England, and the gardens in Chatsworth, home to the Duke of Deovnshire. This gave Henry the idea of creating his own garden. He sketched plans and started planting thousands of trees and plants on his eighty acres in 1857. He began a library and herbarium, which is a collection of dried plant specimens. Some of his plants were imported from Germany.

Henry never married, devoting his life to his garden. He was known as a generous man and donated the land that now contains Tower Grove Park to the City of St. Louis. He sponsored art and programs within the park during his lifetime. He began a botany school at Washington University and established a fund to maintain the garden and keep it safe from being sold after his death.

Henry built a mausoleum on the garden property. He had a horizontal statue of himself constructed near the Tower Grove House. Upon his death he was entombed within the statue. Included among his fifty honorary pallbearers were Adolphus Busch, James Yeatman and William Lemp Sr. He still rests within his beloved garden. His will stipulated that his house be moved to the garden. It was dismantled and carefully moved. It now contains administration and research facilities.

Shaw's Garden is laid out as an English walking garden with a semiformal arrangement. There are gazebos and pagodas scattered throughout the grounds. Twenty thousand trees were planted, and curving driveways cut through the gardens. A straight drive runs down the park's center westward from the Grand entrance with circles containing statues dotting the landscape. The garden's driveways are laid out in a gardenesque style, and, in 1926, the city of St. Louis bought the "villa strip" and added it to the

park, increasing its size to 285 acres and making it the second-largest park in the city.

The park entrances are ornamental gateways with wrought-iron work and stone pylons. Shaw designed the East Gate at Grand in 1870. It is marked with limestone piers topped with zinc weeping lions. Thirty-foot limestone columns at the Tower Grove entrance are topped with limestone bulls and once supported galleries under the dome of the old courthouse. Shaw acquired the columns when the courthouse rotunda was remolded.

At the two-hundred-foot strip are limestone markers erected between 1868 and 1870 with stags on top. A stone gatehouse designed by George Ingham Barnett sits at the Arsenal Street, or South Gate, entrance and dates back to 1870. This was Shaw's final park purchase before his death. Near the gatehouse is one of twelve well houses. In 1872, a water pipe was laid for the City of St. Louis in Arsenal Street and a tap was provided in the park for water.

Shaw took thirty years developing the Missouri Botanical Garden. It holds the world's first geodesic dome greenhouse, the Climatrom, designed in 1959 by R. Buckminster Fuller. The dome maintains a variation of temperatures for a wide variety of tropical vegetation.

Vintage postcard of Shaw's Garden in St. Louis, also called Missouri Botanical Gardens. *Courtesy Janice of Tremeear.*

Other greenhouses include desert, Mediterranean and floral displays. The Linnaean greenhouse built by Shaw hold the camellia collection. Notable outdoor displays are spread throughout, including formal rose gardens, English woodlands and the largest Japanese garden in North America.

Besides his reuse of the columns from the old courthouse, Shaw rescued the limestone blocks from the Lindell House destroyed by fire on March 31, 1867. The *New York Times* described the loss of the four-year-old hotel and commercial site as the greatest calamity since the great fire of St. Louis in 1849. With the help of horticulturist James Gurney, Shaw restacked the fire-scorched blocks to construct the ruins in his garden.

Shaw lived to be ninety; as he grew older he delegated the duties of the garden to others and took up traveling. After he returned from a trip to Mackinac Island, his health deteriorated. In his last weeks he suffered from bouts of fever and slipped in and out of consciousness. Shaw passed away on August 25, 1889.

Shaw is said to continue his care of his beloved garden. He roams the park checking on the status of his land. During the renovation of his mausoleum in 1959, he woke one of the groundskeepers by knocking on his door. When the man went to open the door, no one was there. Once renovation on Shaw's mausoleum stopped, so did the nightly knocking.

Shaw's housekeeper claimed he appeared to her several times after his death. Rebecca Edom said he stood by her bed and called out to her, asking her why she didn't see that his wishes were being carried out. He told her his trees were being cut down and that she needed to go to the garden more to see that this stopped.

He appeared again to ask about his biography, which wasn't completed at the time. Once more he called to Rebecca, this time from a bench in the park. He was dressed in black, his hat in his hand; a rare thing since he was afraid to catch cold and never took it off.

Shaw appeared interested in the spiritualist movement, he was overheard discussing table tipping and rapping with a friend, but it was never confirmed he partook in the belief system that became the rage during the Victorian era. Edom said he appeared to her a year after his previous three visits to direct his wishes on where he wanted his house rebuilt after it was dismantled from Seventh and Locust Streets. Her claims at this time turned from seeing Shaw to merely dreaming of him.

Webster Groves

Edgewood Children's Center

The Edgewood Children's Center sits in the St. Louis suburb of Webster Groves. Its history dates back almost 175 years to 1843 when it served as a orphanage for children who survived the 1832 cholera epidemic but whose parents did not. The St. Louis Association of Ladies for the Relief of Orphan Children created the home for the abandoned little ones in the wake of the many deaths. The asylum was expanded in 1848 and the name changed to St. Louis Protestant Orphans' Asylum.

During the Civil War the group responsible for the home merged with the Western Sanitary Commission, and the group moved from its location in north St. Louis to the Rock House in Webster Groves. The Rock House sat on twenty-three acres of land and carried a full history. The Reverend Artemus Bullard, as a seminarian, constructed it in 1850 for young men. Bullard died in a train wreck in 1855, and it is believed he operated the Rock House as a way station for the Underground Railroad.

A tunnel several blocks long is said to run beneath the Rock House, providing a hiding place for slaves moving to the safe haven of the Northern states. The exit was sealed in the 1890s after two children became lost in the tunnels and died. In 1910, a fire ravaged the Rock House, killing at least one child. The exterior of the building remained undamaged, but the fire gutted the house.

The little girl reputed to have been burned in the fire of 1910 is frequently seen; she is said to be very friendly and the staff calls her Rachel. Footsteps are heard in the hallways of the Rock House, when it's otherwise empty, and up the staircase, which existed nearly a century ago but no longer stands today. Second-floor reports include moving objects, footsteps and oppressive unease. Children are heard playing on the grounds beneath the old cottonwood tree in the early evening. A girl is seen under the tree; some see her floating above the ground.

The facility's name changed in 1944 to Edgewood Children's Center and now serves the needs of emotionally disturbed children. The 155-year-old Rock House located at 330 North Gore Street in Webster Groves is on the National Historic Landmark register.

Another haunting in Webster Groves is of the Theater Guild. A little girl plays tricks on the actors during rehearsals, and an old woman is seen in the basement; it's said the little girl is afraid of her.

On Plant Avenue, a house built near the end of the eighteenth century had several incidents reported during the 1950s and '60s. Heavy pounding was reported on the headboard of the parent's bed. A white light moved through the parent's bedroom and into the room of their daughter. The girl said she had dreams of a man dressed in black who came into her room and spanked her.

During the '70s, a group of teens broke into the house, then vacant. As they tried to leave, the door slammed shut, trapping them. They heard footsteps and laughter; the door opened suddenly and they made a break for it.

Jefferson Barracks

Jefferson Barracks has intrigued people as far back as the Civil War. The site served as hunting grounds of the Fox, Sac, Osage and Sioux Indians. Many famous people have been on the grounds at Jefferson Barracks: General George B. Crittenden, President Jefferson Davis, General Ulysses S. Grant, General Robert E. Lee, William T. Sherman, General Braxton Bragg and President Zachary Taylor. The officer assigned to the Dred Scott case was here; and Chief Blackhawk was imprisoned here in 1832 after being led to the fort by a young lieutenant named Jefferson Davis.

Another haunted St. Louis landmark, Jefferson Barracks was constructed to replace the decrepit Fort Bellefontaine and was once the largest military reservation in the country and the fourth-largest cemetery. The fort became unstable due to constant flooding.

Offering protection from Indian attacks, the new fort was named in honor of Thomas Jefferson. The original buildings were made of stone—damp and cold in the winter and hot in summer. These were replaced during the Spanish-American War by brick buildings.

A National Historical Site, Jefferson Barracks saw its share of hardships. Conditions were crowded, uncomfortable and unsanitary. The Mississippi flooded the marsh nearby, and mosquitoes carried yellow fever and smallpox. Three cholera epidemics, bad surgical procedures and spinal meningitis added to the death toll on the property. Bored soldiers sought diversion with prostitutes, drinking and fighting.

Duels often took place with disastrous results on Bloody Island, named by Charles Dickens because of the many duels that happened there. Neither Illinois nor Missouri claimed the small eyot standing in the middle of the Mississippi. It was the perfect spot to carry out illegal activities.

Ghosts along the Mother Road

Poor food and beatings added to the lack of medical care. Many deserted, jumping onto trains stopping at the fort or stealing boats to cross the river to escape. If caught, the men could be hung by their thumbs, imprisoned in tiny bug-infested cells and shackled. One ghost is said to still inhabit the stockade where he was imprisoned.

An undercover reporter enlisted in the army and was assigned to the barracks. He described the terrible conditions there including the theft of government food by mess agents. Beatings of the enlisted men, including one black soldier who was beaten to death, were exposed by Frank Woodward's front-page article in the *St. Louis Post-Dispatch*.

Because of the report, a military inquiry was launched and conditions changed.

In the Mexican war, Jefferson Barracks was a staging area for troops. During the Civil War, both Jefferson Barracks and the Federal Arsenal stayed true to the government. Soldiers for the Union came to the barracks for training at the outbreak of the war. Soon the facilities degenerated even though the conditions at Jefferson Barracks were better than most hospital and military posts of the time. The barracks switched to a medical post during the Civil War with the addition of nine temporary buildings to house and treat the wounded. Stories of men being permanently crippled by bad surgical conditions and carelessness lend to the tales of ghosts haunting the hospital section of the barracks.

The first parachute jump was at the barracks on March 1, 1912. In the years of World War II, the barracks peaked at 1,518 acres and could billet sixteen officers and fifteen hundred enlisted men and women. It was decommissioned as a military post in 1946 at the end of the war. The post itself is comprised of forty-one buildings on 135 acres. Reports of paranormal activity abound in thirteen of the buildings.

After the barracks were decommissioned, it became part of the Mehlville School District and the hospital converted into a high school. Ghostly footsteps are reported. Lights turn off and on, and an apparition of a young girl is heard wailing in the basement.

One of the ghosts is a Civil War soldier. He's been seen for over sixty years, appearing when large groups of people are present. This may be the ghost who crashed a Halloween party dressed in his uniform. The host spoke to the man and received what he took to be a rude reply. The host turned away from the soldier; when he turned back the man was gone. No such person had been on the guest list.

Footsteps, rustling sounds and people walking around inside the abandoned buildings add to the otherworldly quality of the barracks. A female ghost lives in the old laborers' house, and a Civil War sentry still assumes his post during times of crisis.

There is the sad story of a murdered sentry with a bleeding bullet wound in his head. Killed on guard duty during a raid on the munitions from the quartermasters' warehouse, he appears to soldiers walking their posts. A threatening entity, he confronts those he feels are his enemies and frightens soldiers into dropping their rifles and running.

A ghost avenges the loss of his soul every year on the day of his death. He's seen at the north gate where he met his death at the end of a sword. Strange feelings are experienced. Ghostly sentries are seen patrolling the powder magazine and walking along the stone walls of the now historical museum. This report began back in World War II when the 1857 building was still in use.

During the Civil War a blurry figure was seen walking up a hill from the train yard by a sentry. A Civil War officer has been seen in the headquarters, along with unexplained "strange sounds."

Doors open and close in rapid succession. Unseen hands turn a radio set from a rock station to a country station.

Loud bangs occur in Building 1. An elderly Civil War officer has been spotted, and a shadowy man sits at a desk near a second-story window writing out orders.

Building 29 has a toilet flushing where no toilets exist. A door closed without aid followed by a voice saying, "dismissed." When the area was searched, no one was there. Running has been heard, as well as another voice saying, "Private, come here."

In the chow hall, Building 37, in 1992 at around 7:00 a.m., a black, flowing figure was seen floating down the hall. History on Building 37 says the site was first used as the water works for the post. Water from the Mississippi was pumped by steam engine into four tanks. These one-thousand-gallon tanks were located on the second floor of the building and dispersed to the post by a pipe system. Renovations turned the water works into a guardhouse and jail. Guards used the second floor; the jail was on the first. The garrison side of the first floor housed prisoners who committed general offenses while the general side held soldiers accused of more heinous crimes on post. This side contained an iron cage measuring twenty feet by forty feet. Approximately forty prisoners were held in each room, sleeping on the bare floor, bed slats with no mattresses or hammocks

if any were available. Building 37 often flooded by overflow from the water tanks above. Bedbugs infested the jail.

Building 28 has lights that won't stay off on the third floor. This building housed up to four companies of cavalry soldiers and noncommissioned officers in 1897. Today it's the home of the 218th Engineer Squadron. Ghostly footsteps are heard pacing the corridors—people walking around on the second floor when no one was there.

Building 78, or Atckinson Hall, was the main dining facility in 1912. After the fort closed in 1946, renovations began for the Army Reserve on Building 78. The whimsically named Cockroach Bogey was being given a facelift. A secret room was discovered near the main staircase on the third floor. Papers and records from the early part of the century were inside along with the story of a contractor who committed suicide inside the building.

A World War I soldier has been reported walking around the building looking around. A shadowy figure has been spotted, transparent and looking around the corner at the officer who saw the form.

Buildings 27 and 27A give off feelings of being watched along with muffled footsteps on the stairs, doors moving without wind and a cavalry soldier being spied in the foyer. The man is described as wearing khaki-colored pants, a blue shirt of the Spanish-American War period and a hat.

Ghosts prowl the graveyard of Jefferson Barracks; one is of a young girl seen on a bluff or near the grave of Elizabeth Lash. Elizabeth was buried on August 15, 1827, and it is suspected she passed away due to one of the many epidemics that struck so many down in the city of St. Louis. Is the ghost child Elizabeth? No one knows for sure.

Two soldiers appear at sunset and sometimes in the morning. One is a white man from the South, the other, a black Buffalo Soldier. They are seen rising from their graves, moving toward each other and extending hands in peace and friendship.

CHAPTER 2
EUREKA AND PACIFIC, MISSOURI

SIX FLAGS OVER MID AMERICA

Before Six Flags was the amusement mecca that brought about the closure of St. Louis's Chain of Rocks Park and Highland Hills and took people away from the *Admiral*, the land was a beautiful wilderness. Native Americans who called the land home dug a spring to stave off a drought. Later the area became Deep Spring Stagestop and served as a watering spot for pioneers traveling west.

St. Louis County bought the land decades later, and Irish stonemasons built a large two-story barn that became the St. Louis County Poor Farm. Limestone again played a factor in walls thirty-six inches thick. Today it's part of the restaurant, lounge and meeting rooms of the Ramada Inn at Six Flags.

The hotel is haunted by Aggie (in some accounts her name is Stella), a young girl said to have fallen to her death while the area was still a farm. She is seen running down the halls. A man's ghost appeared to two elderly women; they found the image of him dead and bloated in a bathtub in their room.

Footsteps are heard inside the Empire Theater within the park; paranormal investigators have been touched; and photos of muddy footprints have been taken that belong to one of the five ghosts in the park.

The lady ghost is caught at the Empire Theater, the Palace Theater and in the courtyard behind the Palace. She was seen walking across the courtyard and up the stairs to the door of the security building before disappearing. A

male ghost haunts the same area as this female spirit. While the male seems angry, the female is reportedly friendly and will speak to people. However, if you address this as ghost Stella, as some people do, she becomes angry.

There is another girl within the park—whether she is the same child who haunts the hotel nearby is not known. She plays at the Arbors on the grounds between Thunder River and the Colossus Ferris Wheel. She's been heard giggling throughout the park, but the main sightings are at night after the park closes. She's described as eight to ten years old and wearing a yellow dress with white puff sleeves.

Ghost number four is the one at the Mine Train Roller Coaster. This ghost displays a tendency to open and close the gates or shutdown the ride if the workers say bad things about the spirit.

The Pigman, Bob, is the fifth reported ghost at Six Flags. He was the farmer on the property and raised pigs. Employees have heard the animals and Bob on the back roads of the park.

Other haunts in Eureka are the Eureka 6 Cine, where an apparition appears to workers after hours by showing his face in the projection window.

Pacific

An oddity was reported near Pacific, Missouri, just west of Eureka, in the fall of 2009. This was not the sighting of a ghost but a cryptid. Momo the monster was a Bigfoot-type creature and the rage years ago. Now thought to be false—a tale set by the girls who "discovered" the footprint in their yard—it nevertheless inspired a ride featured at Six Flags.

Another Pacific sighting is of a huge flying creature. The Thunderbird has been reported throughout time and in many states. On the cliffs along the Mississippi River are paintings of the Piasa Bird. The Cahokia Indians, the Mound Builders, depicted this bird, perhaps as a warning from a tribe that conducted human sacrifice. According to the autobiography of Blackhawk there was a cave containing the bones of the victims of this enormous bird. Large enough to carry off a man or deer, the bird preyed on the Native Americans. The painting above the river was called the *Storm Bird* or *Thunder Bird*. The Thunderbird could create a peal of thunder by the mere flap of its wings and shoot lighting from its eyes.

This huge bird lives in legends of the Illini Indians, Sioux, Yaqui, Hoh, Quileute, Mayans, Yeks and Corentyn. Some talk about a creature with a horned head, scales, great beaks and claws that are able to pluck

whales out of the sea. Some say they were giant man-eating bats or large flying serpents.

These creatures may have been condors or pterosaurs by their descriptions. Other possibilities are the animal was a Quetzalcoatlus.

The Piasa painting and description show the body of a dragon, mane of a lion, head of a bearded angry man with sharp teeth, deer antlers and a twelve-foot tail. Some pictures give the creature spiny wings, scales, four bird-like legs and eagle talons. Would this be more dragon than bird? This beast developed a taste for humans after eating dead flesh. It is known as the Bird that Devours Men and is a relative to the Horned Serpent.

The modern-day report states the bird was seen three times near cliffs that contained caves. It was tracking the witnesses and their vehicle while flying about 150 feet up in the air and never farther away than 100 yards. The car was traveling around thirty-five to forty miles an hour. The body was roughly the size of an adult human and brownish gray in color.

Unconnected to Route 66 was a sighting on August 11, 2009, at 11:30 p.m. in northwest Missouri. Similar sightings took place the same night in San Antonio, Texas, of a creature with a wingspan of at least fifteen feet, dark colored and with a very long beak and long thin tail. Other states have their own Thunderbird sightings—Pennsylvania, Louisiana, Illinois, Florida, California, Maryland, Massachusetts and South Carolina—as well as in Mexico.

Some reports list a single creature while others tell of a flock of the giant animals. Dogs have been carried off. Children have been nabbed but released when frantic parents race toward the bird. They are black in color, give off no discernable odor, move very fast for their size and yet move their wings in a very slow, flapping motion. Some birds have long necks while others have a little neck but a long beak.

Who knows what the cryptids may be? The tales of Bigfoot, hellhounds, giant panthers and Thunderbirds pique our interest and spark discussions the same as ghosts.

The Diamonds–Tri County Truck Stop

It's easy to miss now—the once thriving and famous Diamonds. We drove past it when I was a kid. Mom and Dad stopped on trips into St. Louis. And Mom remembers it as a bus stop when she traveled alone to visit my grandparents in Brentwood, Missouri, one of the suburbs of St. Louis.

Mom says the bus would stop to allow folks a chance at the bathrooms and to grab a drink or maybe a very quick bite. She was surprised the old place had ghost stories. All the times she'd been to the place, she'd never heard of any ghosts before I told her. She thought a moment and remembered a time when she and Dad dropped by to eat at the restaurant. She said, "Maybe the place was haunted after all" because when they stopped Dad was fine, but after they ate and left the building "he suddenly became ill and threw up."

Somehow I'm not sure that counts as paranormal, or at least the type of paranormal I've been researching for this book. But I appreciate her sharing the story.

A fruit and veggie stand between Grey Summit and Villa Ridge met the needs of people heading west across Missouri on the Mother Road. Being fifty miles west of St. Louis, the small enterprise attracted a growing tourist trade and blossomed into a restaurant in 1927. Spencer Groof designed the restaurant in the shape of a baseball diamond and named it the Diamonds. He sold gas in a Phillips 66 station and rented twenty-five cabins across the street. The "World's Largest Roadside Restaurant" sported tables and three U-shaped lunch counters with attendants and a cross-country bus service. The menu ranged from hamburgers to roast beef dinners.

Destroyed in 1948 by a fire large enough to temporarily shut down Route 66, the Diamonds was rebuilt; it was *the* place for motorists to stop on Route 66—even big names like Elvis Presley, Al Capone and Marilyn Monroe paid a visit to the eatery.

When Route 66 was decommissioned, the

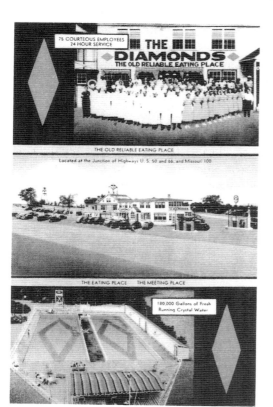

Vintage postcard of Diamonds Restaurant in Villa Ridge, Missouri. *Courtesy Janice Tremeear.*

Ghosts along the Mother Road

Diamonds was moved two miles east and reopened. All that remains of the "new" razed Diamonds is the vintage sign. The rebuilt restaurant on the site of the original Diamonds became the Tri County Truck Stop. Truckers became the mainstay customers for the old Diamonds until newer, easier access truck stops stole the highway traffic. The all-hours restaurant sank into the hangout of the after-hours bar crowd.

The second floor of the Tri County Truck Stop was renovated into rooms and showers. According to the locals, it became the hangout for hitchhikers and prostitutes.

More rumors persist, starting in the seventies with tales of ghostly happenings in the old Diamonds and the surrounding area.

Dan Terry, aka Spookstalker, and his wife, Sherri, shared their experience of a paranormal investigation at the Tri County Truck Stop with a St. Louis-based group called MPR.

In Dan's account of an interview with a former employee, she claimed someone or something would watch her every time she went into the basement. She heard growling downstairs and was prevented from leaving the restroom upstairs, as if someone was holding the door shut. Her hair was pulled, and when found by another waitress her braid had been pulled loose from her head.

While Dan was there, pots and pans rattled in the kitchen. An investigator saw a flash sink into the floor, and the EVP "Good" was captured on digital recording. Returning a few weeks later during the day with MPR and a new reporter, an old knife lying on the floor suddenly flew at them as if thrown.

On yet another return to the old Diamonds restaurant, an orb was seen crossing the room and disappearing into the wall; later a rock was tossed against a back wall. Pipes shook after the investigators questioned the spirits, asking for them to make themselves known by making a noise. One investigator had been shoved upstairs, and Dan watched a shadow figure on the wall to his right. The shadow man seemed to move above Dan's head as he confronted it by blocking its path.

Tales of a man known as George are told. He moves things and touches people. Black shadows are seen moving in the buildings, along with a blue form. A man who went by the name of William Bates throws items. He is the stuff of urban legends—possibly a solider or a vagrant and tall, lanky and with a blank look. As with all urban legends, he carries an air of mystery, for no one seems to know who he was or where he came from. Moreover, why was he allowed, as the stories say, to stay in the basement? He was a man of temper and quickly tossed things at people. Dan Terry reports that Bates

allegedly threw a knife at a crime family boss, striking him with the butt of the handle. Bates fled with men in pursuit.

No one seems to know of his fate. People report yellow eyes staring at them in a restroom, mists, tiny figures, moving furniture, doors opening and closing of their own accord and feelings of dread. Some of the restaurant equipment is said to turn on by itself, and voices are heard.

One of the most unusual tales is of a child who witnessed a murder. In 2006, something malevolent came out of the basement. A boy and his mother walked down the hall to the restroom and up on the stairway leading to the office and rooms above. He saw a man with a knife to a woman's throat. The boy asked if his mother saw the man on the stairs. She said no; then the boy asked his mother to save the lady—the man was going to cut her.

Another version has the boy going the restroom alone. He saw the man slice the knife across the woman's throat, and blood sprayed everywhere. The child screamed and ran back into the restaurant. People ran back to the area to search, and all they found was splatters of a red liquid that wasn't of any substance connected to the restaurant. The substance was hard to clean off and flecks are said to remain.

A child has been heard in the building, possibly a little girl. Cans in the pantry have been rearranged; cold foods on the buffet table are switched to other locations; office chairs swivel with no one seated in them; and people are slapped and shoved.

Some folks who live nearby claim ghosts spill over into their homes, and there is a hitchhiker along Highway 100. The man will ask to be taken to the truck stop and then disappear.

The shadowy form of a panther is claimed to been seen in the basement of the Diamonds. What are these ghosts? What causes them to haunt the once-lavish restaurant, or could the tales be the products of years of legends brought by road-weary travelers? Perhaps a deeper look into the land surrounding the Diamonds might uncover the reason behind the hitchhiker and the spirits neighbors see in their homes.

Today the Tri County Truck Stop is a ghost in its own right, a pale shell of what it was in its glory days. Closed, used as storage and boarded up to cover the broken windows, the building still sits west of Exit 251.

I doubt my mom would recognize it now. Dean and I passed it without noticing because of the interstate, gas stations and fast-food places at the exit. From I-44 we jumped onto Highway 100, looping north and west around and beyond the Diamonds, heading for Washington, Missouri. I knew the area well; I spent many years living approximately fifteen miles north of

Ghosts along the Mother Road

Diamonds–Tri County Truck Stop. *Courtesy of Janice Tremeear.*

Washington in Warrenton, Missouri, raising my family. I knew we'd missed the restaurant—the road was changed and a new addition bypassed the old route, as so many four lanes do—and we'd driven beyond the turnoff.

I was used to seeing it when family trips were taken to Six Flags. It was a beautiful building and reminded me of the architecture of the Coral Court Motel in St. Louis, also a Route 66 landmark that is now gone, taking with it the tales of suicides, murders, Mafia dealings and affairs. The Court bore a graceful, art nouveau window treatment, and so did the rebuilt Diamonds.

As we drove down 100, I knew we had to turn back, the road had been widened to handle the increase in traffic and bypass the route I had taken when my then husband and I took the kids to Six Flags. We found a quirky turn off the old 100 and headed back east. At the top of a hill just beyond a residential area I caught a glimpse of the back of a hulking structure squatting on the hill. I recognized the Diamonds—we had found it.

The restaurant sits at the apex of two roads, traffic speeding past—only now nobody stops for a meal or coffee.

CHAPTER 3
DEFIANCE AND UNION, MISSOURI

Daniel Boone Village

After leaving the Diamonds behind, take a trip west into Washington, Missouri, and then north on Highway 47 across the Missouri River for a side trip.

One the north side of the Missouri you'll drive through the river valley and past bluffs to the east, where the small town of Dutzow sits high above. In the flats just west of 47 is a pond, usually full of water. To those who are merely passing through it looks like a serene home for geese and marsh-loving animals. But if you were a resident of the area, like me, you remember when the pond didn't exist, when it was part of the field as the rest of the farmland surrounding it.

When the road crews were working on 47, they parked their equipment in the unplowed field overnight. Little did they know what they would find one morning: a sinkhole had opened beneath one of their equipment and swallowed them. Some were towed out, but one huge Caterpillar remained, much too heavy and awkward to be hauled back to the surface. We drove by for months watching the exposed portion of the machine slowly disappear into the ground as the cave below opened wider and deeper. Finally, only a tiny tip of the CAT could be seen. Now, nothing remains to show what had rested above ground before one of Missouri's infamous sinkholes appeared.

There is nothing haunted about that particular location—just an interesting story. But continue up 47, part of the Lewis and Clark Trail, and turn right just over a small bridge onto D to travel to the Daniel

Boone Village. Continue west on 47 to see Daniel's home and his grave site high on a bluff. But the ghosts that are talked about linger in the historic Boonesfield Village.

Daniel was only about five foot eight—the people of his time were generally much shorter than we are today, evident by the short bed in the Daniel Boone Home in the village. I was surprised at the child-sized bed in the master bedroom.

The house is actually his son Nathan's home. On part of the 850 acres of land given to Daniel via a Spanish land grant. Boonesville Village and the mansion are on the National Historic Site Register. The home is almost two hundred years old, four stories tall and built of limestone walls that are two and a half feet thick.

The kitchen is in the basement, and the walls are equipped with murder holes to allow the residents to shoot at Indians or other intruders from the safety of the house. A dozen other buildings have been moved to the site from within fifty miles of the area to comprise the village. There is a gristmill, schoolhouse, carpenter's shop and the Old Peace Church onsite.

Daniel was sixty-nine when work on the house began. He built a coffin for himself of black walnut and donated it for neighbor who died suddenly. His new coffin was cherrywood and kept in the cabin Daniel built for himself and his wife, Rebecca, not far from Nathan's home.

Rebecca passed away on March 18, 1813; Daniel died September 26, 1820, at the age of eighty-six.

When we visited, the guide told us the story of Daniel's grave site. We climbed the steep stairway to the top of the bluff to view the spot where Rebecca and Daniel lay. He said Tennessee disputed Missouri's claim to Mr. Boone and came for the body.

The remains next to Rebecca's were removed in the belief they had Daniel in their possession. According to our guide, what they didn't know was an Indian was already buried at that location when Rebecca was laid to rest. So Daniel was placed crossways at her feet. The Indian was taken back to Tennessee, not Daniel.

A friend of mine, Visnja McCullar, and her husband, Bill, paid a visit to Boonesville Village in 2009. V and Bill take part in paranormal investigations whenever the opportunity arises, and when they toured the village she asked the guide if the place was haunted. He told her it was but said so unofficially, of course.

During the slow season, when only one employee is present, doors are heard slamming on the third floor, even with all interior doors propped open

Ghosts along the Mother Road

Vintage postcard of Daniel Boone Mansion's dining room at Daniel Boone Village in Defiance, Missouri. *Courtesy of Janice Tremeear.*

by doorstops. The ballroom on the fourth floor is filled with violin music. Volunteers sleeping in the home during candlelight tours hear pots and pans clanking as if they've fallen.

Candles are seen lit near the anniversary of Daniel's death. Authorities called to investigate the sightings found no one; yet the dim lights are seen, especially in the granddaughter's bedroom.

There is a door on the outside of the third floor that locks people out if the spirits don't want you inside the house. The door is not locked but it will not open until minutes later.

Tour guides' aprons are untied by unseen hands; objects are moved; faces are seen in the windows; and the requisite lady in white that so many haunted locations boast is on the grounds of the village and paying her respects in the cemetery across from the house.

It is surmised that possibly two of Nathan's daughters are buried in the cemetery and many have seen the woman in white in the evening. Her features are never clear, but no one feels any sense of dread or fear from the spirits that dwell at Boone Village.

Union

Travel south back to Washington and into Union on Highway 47. Here the Union Screaming House is located. This was a private residence built in 1936 on land owned by Captain John T. Crow and was often called the White House.

Captain Crow began the Missouri Militia during the Civil War. The house stands on what used to be the slave quarters, and near the property was the Franklin County Poor House, a former infirmary. Like most of the poorhouses in the country, those who died there were buried in unmarked graves or listed for the St. Louis Poor House; some of the bodies were given over to the medical schools. Folklore says souls buried in such a fashion—or not buried in a Christian manner at all—cannot find peace and are doomed to roam the earth.

A murder–suicide is said to have happened in the house across the street, with other suicides occurring in the vicinity. This is the setting for Steven LaChance's book *The Uninvited* about his extreme haunting and the help he gave to the next tenant.

CHAPTER 4
MORSE MILL, MISSOURI

About twenty miles south of St. Clair, the town of Morse Mill is off Route 66 and is an interesting side trip for those who wish to explore a piece of haunting history. From Union, travel south on Highway 47 to I-44. The city of St. Clair sits at the junction of 47 and the interstate. Then south on 30 into the Meramac River Valley toward Hillsboro is the former resort area of Morse Mill at the banks of the Big River.

The small community is named after John H. Morse of Massachusetts, who settled in 1847 and built the mill next to the river. He was a farmer and miller, ran the general store and was postmaster for a time. He fought for the Confederacy and was later a state senator for Jefferson and Washington Counties.

Morse built Gravois Road and the Sandy Creek Covered Bridge in 1872 on Old Lemay Ferry Road. The bridge, restored as an important historic landmark, provided a link to Jefferson County's road system. He also built the iron-framed Morse Mill Bridge that still spans the Big River; however, it is closed to all except foot traffic. The bridge is a short walk from the hotel, and when looking back across the river one can see the foundation of the former mill near the riverbank. A private home occupies the yard above the crumbling foundation. The mill was closed during the Depression and torn down in the 1940s. It had been the longest-running and most prosperous mill in southeast Missouri. On one of our visits Andrew pointed out an odd thing on the bridge: an old, frayed rope hung from one of the overhead beams. The sight gave us gruesome speculations. What might its purpose have been?

The house began as a two-story home in 1816 and served as a Confederate field hospital in the Civil War. In the 1870s, it grew into a four-story, maple and limestone, 5,300-square-foot house with a New Orleans–style balcony on the second floor. The limestone wall in front of the house is said to be hand carved by slaves. The twenty-five-room Morse Mill Hotel has a long and colorful history. Jesse and Frank James stayed there many times, calling it the James Hotel, and made their marks in the register. Charles Lindbergh and Clara Bow, the It Girl, stayed here. Charlie Chaplin came to the hotel and is said to have been a womanizer. Those traveling from St. Louis would have taken Route 66 part way to their vacation site.

In gathering the photos to be used in this book, I found a great vintage postcard of the mill. The scene is set looking at the mill from across the river, the water flowing over a small set of rapids or rock dam; ladies and gentlemen in Victorian-style clothing stand at the riverbank with parasols shading them from the sun. Small rapids and people wading in the water over the rock ledge paint a beautiful afternoon on the riverbank.

During the Roaring Twenties, the house was used as a hotel, and Big River became a resort town. Al Capone has been traced to the hotel, using it for his gambling and whiskey operations. During Capone's time the cops avoided the area, according to legend.

The hotel was also a halfway house, speakeasy and gambling house during Prohibition and a brothel at least twice. It's said there are Indian burial grounds located here, and it was part of the Underground Railroad.

Bertha Gifford worked at the hotel in the 1950s. She is one of the first female serial killers in America. Arsenic-laden chocolate was her poison of choice, doled out to children. Her first-known victim was her husband, who was killed at the hotel. She is credited with killing over twenty adults and children. She was arrested on August 25, 1928, at the age of fifty. She was a great beauty and wonderful cook. Her murder trial was held in Union, Missouri. She was decreed insane and committed to a mental institution in Farmington. She never left. Bertha died in 1951. We visited her grave, located within walking distance of the hotel.

Other stories include murders, suicides and hangings on the property. A former tenant says that during the time she lived at the hotel the post office was in the basement and the postmaster was killed onsite.

There are many and varied accounts surrounding the old hotel. Footsteps are heard both up in the attic and down in the basement. Shadows are seen moving throughout the building.

Bertha Gifford's tombstone in Morse Mill, Missouri. *Courtesy of Janice Tremeear.*

People have been touched, shoved and scratched. Voices whisper in your ear. Someone breathes on the back of your neck. In room 4, men can be inappropriately touched; it is believed this was once the room belonging to a call girl during its stint as a brothel. On a previous investigation with another team one male member found his pants being unzipped repeatedly while in this room. Others witnessed his distress. It is said records exist showing a prostitute was beaten to death by an outlaw inside the hotel. Clothes are pulled. In one of the numberless rooms on the second floor, a large shadow man was seen when the door was opened.

A heavy-duty lock was pried and twisted off the door on the second floor. A fireplace poker was found bent into a *U* shape. A shadow of a man wearing a hat was seen at the end of the hall near room 12.

The image of a woman is seen in the attic. An elderly woman, veiled, is seen crouching at the widows' peak, staring out toward the river—neighbors report seeing this figure during the daytime when the house is empty and locked.

Orange balls of light have been seen in the attic; sounds of being followed up the basement stairs are heard and one can feel being poked; and music is played then repeated on digital recordings.

A girl is seen in the basement.

We've seen children on the stairs and darting shadows in our video camera lights on the second floor. Our video camera has been prodded and bumped several times. A shadow has darted across in front of the second-floor camera that also caught a child's giggle. My recorder on a table next to the stairs on the first floor captured the giggle at the same time stamp. The building was completely empty at the time; our team had driven into town to buy extra cables.

Growling is heard in the basement, coming from a windowless room, and glimpses of shadowy movement are seen in what is considered the old slave quarters, or root cellar. Witnesses and former residents say this was a storage room and a wine cellar in the 1960s.

Shadow people are seen outside the building by the tree with the tire swings and down on the flat area used for overnight camping, next to the woods and river. We've attempted to chase down these forms moving about on the hotel grounds.

Tapping occurs on the glass windows during the daytime. Neighbors see human shapes on balconies and back stairs and no one is there.

Temperatures dropped near Alicia when she felt something touch her.

A large man's shape is seen in the basement.

Investigators who are rude get tossed across the room, and a few burly men have been found sobbing in the basement after spending time alone in the area.

Music played on the piano is heard repeated on recordings, played by other instruments.

We have an EVP (electronic voice phenomena) capture of a woman speaking what appears to be Latin.

Children are heard playing in the building.

Route 66 Paranormal Alliance has been to the old Morse Mill hotel. We spend the night and sleep in the front room, the Piano Room as it's called, where some fear to sleep because of being scratched. The bent poker still sits in the cold, unused fireplace, and the piano occupies a corner waiting for a tune.

I've had the blankets pulled off me by what feels like a small, child-sized hand. Once, while I was on the couch trying to sleep, Charlene and Ken shared the air mattress on the floor next to me and Ali and Andrew slept near the front door, the sound of little feet walked between Charlene and me. We both looked up in the direction of the footsteps at the same time. "Did you?" I started to ask. Charlene said, "Yes, something walked right there." I felt a small hand touch my cheek, and when I told Ali, co-founder

Ghosts along the Mother Road

Morse Mill Hotel. *Courtesy of Janice Tremeear.*

of Route 66 PAL, that something was touching me she snapped a photo that showed a white streak or mist at my cheek exactly where I pointed out the feeling of contact. I've been told a recording exists of a young girl asking, "Where's Janice?" after I'd been to the hotel.

The neighbors appear frightened of the place and lurk about outside waiting to talk to us, to show us photos they've taken of orbs and mists around the outside of the place. The orbs are likely dust, moisture or bugs. We calm them by explaining what they have probably caught with their cameras. But what about the shadows they've seen, and the noises emitting from the empty building? There is no water and no electricity to the place—yet lights are reported through the windows. While we're present, the neighbors brave a walk-through of the interior of the building before dark. We listen to their stories of the place and are told ghostly happenings spread throughout the area.

We don't tell them we've been touched while inside the hotel, about the shadow figures that appear to be watching us or about someone asking for me by name. They live here, just across the street; they live with the presence of the once grand hotel and its occupants. We know the next morning we can pack up and go home.

In doing research for this book I came across other tales about the town of Morse Mill. In 1968, the hotel was a private residence and not haunted at the time. An elderly woman had lived there; her grandson lived in Washington, D.C.

The man's wife dreamed of a young girl with long blonde hair and bangs. She was about eight years old, screaming as a Queen Anne chair tipped forward as its right front leg broke.

Knowing something was wrong at the hotel, she told her husband about the dream. At 7:30 in the morning the call came: the elderly woman had died during the night. She'd been sickly and was in a nursing home at the time.

When the family came to the hotel to take care of the woman's belongings, there sat the chair from the dream, in one of the back rooms that once had been a three-room apartment. The right front leg was missing, with a board taking its place to prop up the chair.

Since the present owner has been renovating the old hotel, the activity seems to be ramping up enough to cause him to contact paranormal investigators. The documentary *The Morse Mill Project* came about as a result, and the hotel is to be featured on the Travel Channel's *Most Terrifying Places in America*.

The description of the little girl from the dream matches reports given by several people who've recently been to the hotel and dubbed the girl Rachel. She makes herself known to many and may be the person who touched my cheek and darted in front of our cameras.

One more tale of the area of Morse Mill is the Indian princess from the local folklore who is supposed to have died on a sixty-acre farm, more than one hundred years old. Much like gremlins in the mix, the princess was blamed for any mishaps that occurred at the farm. The folklore continued with tales of the home being built on an Indian mound and that some former owners had been involved with black magic, with a room painted black and moon signs and the pentagram drawn on the floor.

Items would go missing; lights would come on by themselves after being turned off. If you asked the princess to return any object that was lost it would turn up moments later. There were feelings of dread; an eerie, just "not right" atmosphere lingered in the home.

No one knows if the legends of the princess or the black magic practitioners have any truth to them.

The former postmaster, Alice I. Lee, has written about how a trip through Morse Mill in its heyday took longer to drive than it took to drive from the town to Festus. The resort died when the Lake of the Ozarks took vacationers

Ghosts along the Mother Road

A drawing of Rachel, as reported by witnesses. *Courtesy of Jeanna Barker.*

and their money away from Big River. New highways bypassed the town in the '60s. In 1993, a flood caused considerable damage.

The resort glitz of the once thriving burg is long gone; no signs of the casino and the thriving liquor business remain.

CHAPTER 5
STANTON, MISSOURI

Meramec Caverns

Meramec River snakes through the hills and valleys of Missouri. In 1720, French explorer Philipp Renault was told by his Osage guide of a hole cut into the earth near the river. The gigantic room sheltered the Indians in times of extreme weather. They spoke of the walls with veins glittering with yellow metal. Naturally this got Renault's attention. As Renault's boat neared the shore of the Meramec, he saw the gaping hole, fifty feet wide and twenty feet high. This was the entrance to the largest cave west of the Mississippi, Meramec Caverns.

There was no gold, as the story led Renault to believe, but saltpeter. He named the cave Saltpeter Cave after the mineral that led to mining what is otherwise known as potassium nitrate, a key ingredient for gunpowder of that age. Disputes over control of the cave bled into the years of the Civil War. Confederate forces destroyed a Union gunpowder facility inside the cave, and the mining operations halted.

In the 1890s, people from nearby Stanton would hold cave parties to escape the Missouri heat of summer. A large room exists just three hundred feet inside the entrance and became the Ballroom, with a fifty- by fifty-foot dance floor in the center.

Charles Ruepple bought the cave in 1898 and continued the dance parties held in the cave.

Lester Benton Dill spent many of his summers exploring caves in the Meramec River Valley. He promoted Fisher's Cave within the state park and, in 1933, approached Charles with an offer to buy Saltpeter Cave. After Charles agreed to sell, Dill changed the cave's name to Meramec Caverns and planned to promote it as a showplace to the public. Also in 1933, Dill discovered a small crack in one of the walls with a breeze blowing from it. He shouted through the opening to see if his voice would echo back; when he heard the echo he knew there was another opening beyond the crevice. The wall was removed, and one of the amazing discoveries Dill found was the world-renowned Stage Curtain.

I've walked behind the Curtain when the tours allowed people to move behind the huge seventy-foot-tall stalagmite formation. There was a narrow walkway constructed, and one had the sense of moving between the side of a bluff and a stone waterfall. The room that holds the Stage Curtain is called the Theater Room, and Dill built his show cave around his new discovery. Eight years later the water table in Missouri dropped due a severe drought. The waters inside Meramec Caverns receded in 1941, appearing to dead end at a wall. With the dropping of the water level a breeze blew beneath the wall.

When Dill went beneath the wall into the water to see what lay beyond, he found even more caves and artifacts that traced back to Jesse and Frank James. The cave was then dubbed Jesse James Hideout, and the Jesse James Wax Museum soon opened in Stanton in 1941 on I-44 at the 230 exit.

A lower level to the cave was found and opened in 1947. Dill also began the nationwide promotion of the cave with the barnside paintings advertising his famous caverns. He pioneered the use of bumper stickers.

When the Routt family (my maiden name) visited the cave, we would return from our tour to find complementary bumpers stickers attached to our car.

Today there are seven known levels to the cave. On the tour I took as a kid, there were levels you could only view overhead—the openings and rooms were too small.

The ghosts are not as well advertised as the cave. On our tour the guide would tell you that the very last tour of the day would hear voices. I've been on many cave tours, and you can hear the tour just ahead of you and the one coming up behind. But these voices are from a tour that doesn't exist. You are the very last tour, and there is no one following you.

Lights are said to flicker when no one is near the switch. The former owner of the cave is reported seen; Lester B. Dill still pokes around his pride and joy to oversee the daily operations of his beauty.

In total darkness people are heard running through the cave, which is hard to do on the slick floors even with the use of the hands rails for safety; drafts come from areas where no opening exists and strange sounds are heard; children and adults are heard screaming; and there are feelings of being watched.

Children on the tours say they can see people where no one is standing. Adults walk off the tours because they hear children laughing in the cave.

Many have drowned nearby. A Civil War battle was fought, and the cave was used as a bandit hideout. It's said the founder of Sullivan was hanged at the cave entrance.

No wonder the cave is restless, but you won't see that information painted on a barn alongside the highway.

CHAPTER 6
SULLIVAN, MISSOURI

Harney Mansion

In Sullivan, Missouri, stands a one-hundred-year-old mansion that was the summer home of General William Shelby Harney. Harney's father served in the Revolutionary War as a major. Young William began his military career at eighteen as a lieutenant under James Monroe. He chased the pirate Jean Lafitte from the shores of Florida with Andrew Jackson, his childhood neighbor in Tennessee. He also fought in the Seminole War in Florida.

Harney was soon promoted to captain, negotiated peace with the Iowa Indians and served with Jefferson Davis and Abraham Lincoln.

Harney was charged for the beating death of a female slave in his household. The trial was in St. Louis; no record was recorded, perhaps to protect a man whose reputation was becoming larger than life.

He tracked down the Caloosa Indian chief for reneging on the peace treaty, had him shot and brought back his body, scalped and hung alongside two more warriors from the village. Harney blamed the secretary of war for causing the chief to go to war by going back on the treaty.

He was the commanding officer at the Battle of Ash Hallow resulting in eighty-five men, women and children being killed. He earned the nickname Butcher of the Brules. Harney displayed quite a temper and showed very little mercy to those captured in battle.

His military career covered the Red Cloud Uprising of 1827, the Winnebago Indian War of 1828, the Black Hawk War of 1832, the Seminole Indian War of 1836–1841, the Mexican War of 1846–1848, first Sioux

expedition in 1855, the Mormon expedition of 1858 and the San Ivan affair of 1859–1860.

Harney retired in 1863 and was brevetted to major general in 1865. Lincoln said removing Harney was one of the greatest mistakes of his administration.

William Harney bought the mansion from a St. Louis doctor by the name of Alson Leffingwell, who built the home in 1856. Harney added to it in 1872. It served as his summer home until 1874 when he moved to Florida. When we were at the mansion, our guide said Harney entertained at the mansion; one of his more famous guests was General Grant.

The mansion is an elongated asymmetrical structure, one and three-fourths stories with a wing, assumed to be the kitchen area, attached at the rear of the house.

Built in two sections by two different owners, the home is entirely native brown sandstone; the wall is about twenty inches thick. The home is built in the Massachusetts colonial architectural style.

There is a primary bay in the 1856 section of the home with a large arched entrance at both ends of the house, to allow carriages to pass through. Fanlight windows sit over the double doors.

Originally there was a portico at the side of the house; it is long gone, but the second-floor doorway still exists. The top-floor windows are boarded over, with the glass missing until renovations are completed.

One of the two staircases to the top floor remains on the south end. It winds up and around to the second floor from a narrow hallway, reminiscent of a servants' staircase. Harney duplicated a second staircase on the north side. This stairwell is no longer there; the north end is being converted into smaller, office-sized rooms. An "ell" was added onto the rear of the house for kitchen and servants; mostly destroyed now, the outline of the area remains.

When I was inside the mansion, one of the back rooms on the southern end contained wood from the home that was stored during renovations and an old dentist chair with the leather seat still fairly intact. On the bottom step of the stairs to the top floor sat denture forms, lending an odd and slightly creepy effect to the pitch-black hall and stairwell. The stairs had partially crumbled from age, and to proceed to the top floor required great care to not fall through the stairs. The rooms above were not to be entered, as the floors had decayed and only the hallway remained safe to walk on. The ceiling on the upper floor was opened beneath the rafters, allowing birds and bats to enter.

Ghosts along the Mother Road

Harney Mansion, with the author in the foreground, in Sullivan, Missouri. *Courtesy of Dean Pestana.*

The upper floor contains a narrow hallway running the length north to south with decaying rooms on either side. Our guide said this area was a dormitory for girls. The boys stayed in a house across the street.

People who have lived in the Sullivan area for many years know of a rumor of a tunnel connecting the two buildings. I was told this is urban legend only.

A small cemetery is located behind the mansion, the stones removed years ago.

Haunting figures are seen at the upstairs windows even though today they are boarded over. Glowing lights are seen inside the mansion, often from a distance in the windows. Mists and orbs are reported and recorded in photos and videos while taking a tour of the mansion.

Strange odors are present such as pipe tobacco and the fragrance of lilac; people feel they have been touched; and apparitions of a male and female are seen inside the home, and they appear to glow—at times they appear to be fully aware of the people around them, while other reports give the indication the couple is a residual haunting, which is a recording of past events and not sentient in any manner.

Noises ring in the structure: walking, the sound of boots, children running and laughing, and items being moved. Shadows, darker than the

dark (portions of the mansion are without electricity) have been seen. Black masses have been photographed. Cold spots appear in the house with extreme drops in temperature.

It is thought the mansion housed threes spirits, the male and female and a younger male about eighteen years of age.

Dan Terry also took part in an investigation of the Harney Mansion. In the information he sent me, he reports a video of moving shadows and a mirror that appeared to change the image inside with each shot, including an unidentified face. This investigation also offered up a photo with a white hand-like mist around the ankle of one of the investigators. A weight suspended from a string in one doorway began spinning in large circles, blurring with speed.

Black masses have been photographed up through the missing floorboards into the second floor; faces are reported peering down at people through the missing floor; sounds of music have been heard in the building, with its main portion containing the double doors used as a ballroom; and thumping noises, knocks and draining batteries are also reported onsite.

Harney died while living in Florida, but could his spirit have returned to the site where he spent many summers entertaining his guests?

Chapter 7
Rolla, Missouri

Goatman's Grave

Rolla, Missouri, is a college town centrally located in Missouri about one hundred miles from St. Louis, Springfield, Jefferson City and Columbia. The city was an important site during the Civil War. The southwest branch of the Pacific Railroad ended here. The town leaned toward the Confederacy. The Union took over the city in June 1861 and built two small forts, Fort Wyman and Fort Dette.

A half-size replica of Stonehenge is here on the University of Missouri campus.

There is a report of ghostly activity in the Rolla hospital. A young man has been seen standing in a corner, not moving; he was later seen in the same corner and hadn't moved from the spot. Footsteps have been heard in the empty halls; faucets randomly turn on; and noises like dropping coins occur in the hallways in the older portion of the building.

One of the more interesting accounts of odd activity is the Goatman's Grave story. The site is located about 10.3 miles east of Rolla or a few miles south of St. James. The locals call the location Spook Hollow.

A goatman haunts the graveyard, appearing out of nowhere and then disappearing just as quickly. A phantom car is said to chase you on the road leading to the graveyard only to vanish suddenly as it's closing in on your vehicle. There is an old bus nearby said to contain red, glowing eyes, though some say this is a mere reflection from bottles in the windows.

A figure is seen walking along Country Road 3450 that runs north of the cemetery and past the abandoned bus. It's been said this was a hobo who once lived in the bus. The cemetery is actually named Pine Hill Cemetery and is located at Pine Hill Road and Country Road 3450, south on 3470 on a short, dead-end road.

When venturing into the cemetery, all electronics are drained of battery life incredibly fast. People become lightheaded and dizzy; they experience uneasiness and have the sound of wind in their ears.

I asked for information of the urban legend of the goatman of Rolla. Jayson Journey answered my inquiries and said the investigative team he is with—SNIPE (Supernatural Investigators of Paranormal Environments), with members Martin Maxwell, Jason Kelley and Josh Klouzek—have been to Pine Hill Cemetery. Jayson has family buried there and felt as if they were watching him.

He reports a fluctuation in temperature at the site, and after they preceded into the cemetery about ten feet the camera died even with brand-new batteries. The team went during the daylight hours and found very old graves with odd things written on the tombstones. He thinks a lot of people simply scare themselves by forgetting they are out in the middle of the woods when they go the graveyard.

Dean Pestana, a member of Route 66 Paranormal Alliance, grew up in Rolla and heard tales of the infamous goatman. The tale has been around for years. Here is a version of the tale in Dean's own words.

> *Growing up in Rolla, there was not a lot to do. So when something unusual turned up, we naturally were interested. One thing we heard about for years was the legend of Goatman. It was something everyone knew about, but didn't take seriously, most of the time. You would hear of people saying they saw Goatman, or had just escaped him. The theory was that Goatman could catch you whether you were on foot or in a car, as long as you were in the grass or on a gravel road. Once he got on pavement however, it was said his hooves slipped, and you could escape. I remember three friends going out to find Goatman, laughing about how they didn't believe he was real. Nothing happened by the graveyard where he was said to lurk, until they were leaving. A loud pounding was heard on the back of the car, and one of them, a fearless jock, was yelling and screaming like crazy. Panicked, they left in a hurry. Upon getting back to town there were found to be some dents on the trunk of the car (a sturdy mid 70's Nova) that were somewhat hoof shaped. Not conclusive proof, but it added to the legend, and the spice*

Ghosts along the Mother Road

of visiting the area Goatman is supposed to haunt. Today, Goatman is still talked about, haunting an area said to contain a disappearing car on the way to the spooky graveyard.

DEVIL'S ELBOW

Although small boats could navigate the rivers in the Ozark hills, the larger steamboats could not pass. When the logging industry was in full bloom in the hills, certain men became renowned as tie hackers in the nineteenth century. Logs were cut out of the best oak by thinning the forest. The logs were sawed into uniform ties, tied together to form a raft and then guided down the fast rivers to St. Louis. Anyone who has fished or rafted the Ozark waterways knows the twists and turns, shallows and deep holes of water in these smaller rivers. One of my favorite summer pastimes has been canoeing along some

Vintage postcard showing views of Route 66 in Rolla, Missouri; Devil's Elbow Café; Jensen's Point in Pacific, Missouri; and Twin Bridges across Bourbeuse River. *Courtesy of Janice Tremeear.*

of the Missouri rivers. One day the rapids might be overwhelmingly fast and the next there could only be a trickle, and you'd have to drag your canoe across the gravel bar. Much depends on the fickle Missouri weather and the level of the water table.

During the winter, tie hacking was particularly dangerous. Bends in the Big Piney were named for their bloody history like Pike's Defeat, Crooked Shute and Devil's Elbow. A large boulder sat in the middle of the river, causing many problems for the loggers.

Realtor.com in 2009 listed Devil's Elbow, Missouri, as no. 12 in the Top 50 Scariest City Names.

Mayfield Cemetery, two miles south of Devil's Elbow between Lost Hill and the railroad tracks, is haunted. The town of Mayfield existed at the edge of Big Piney River in the Mark Twain Forest before Fort Leonard Wood was built, and the area was used for training.

All that is left is the cemetery with tombstones so old the writing is weathered and worn away. Many are from the 1800s, with several children's graves, the result of untreated disease in that era.

Mayfield Cemetery is just off I-44 on J highway. It is not marked and is accessed via a National Forest Service road. About one mile before the cemetery is a solitary tombstone on the left side of the road. The grave is raised with flat rock three feet high around it. The grave belongs to Eliza Jane Thomas, wife of Henry Laycook, who died in 1897. Her name is carved

Vintage postcard of Hooker's Cut on Route 66, a section between Rolla and Lebanon, Missouri. *Courtesy of Janice Tremeear.*

into the rock by her grave. She was reported to be a witch and therefore not buried within the holy ground of the cemetery. Some of the activity in this area includes claw marks on campers' tents and disembodied voices.

Hooker's Cut was considered the deepest slice created to build a road in its day. This section was cut into the hills to straighten Route 66 near Devil's Elbow and create a safer travel environment.

Devil's Elbow is one of the most beautiful and scenic sections of Route 66 and possibly one of the most feared and dangerous portions of the highway. Devil's Elbow became a resort area when the Mother Road was well traveled in the 1930s and '40s. Today the Devil's Elbow Inn is a well-known biker bar decorated by countless bras hanging from the ceiling. Route 66 in the near ghost town community is called Teardrop Road in the elbow.

Like a movie filled with Ozark voodoo tales, floating heads bob in the river—the heads sink and don't resurface. They are supposed to be the men who died while navigating the treacherous waters during the logging days. Other images are seen just below the water's surface, and sounds of laughter or crying are carried by the winds. And the banshee-like wail of a female calls out an indistinct name.

Fort Leonard Wood

Construction began in December 1940 on a new military training facility named after Major General Leonard Wood. He graduated from Harvard Medical School and was the commander of the Rough Riders during the Spanish-American War. Later he was the governor of Cuba and the chief of staff for the army from 1910 to 1914.

The fort covers seventy-one thousand acres and took over many small towns in the area. Bloodland was one of these towns. Approximately one hundred residents and forty buildings comprised the old settlement. The German descendants gathered at Halloween night October 1940 to learn their town was in jeopardy. Outraged, the citizens went on a drinking binge that erupted into a small riot. This set the groundwork for the legends that followed.

In 1942, a soldier named James Klown was court-martialed for being drunk while on duty. He was patrolling the area of the fort once part of Bloodland. He said he heard strange noises nearby, and when he investigated, riotous ghosts speaking a language he didn't understand captured him. He was forced to drink hard cider through a straw until he passed out.

The very next year another soldier, Randall Ellsworth, experienced the same riot-forced drunkenness. This action forced the fort commanders to place the haunted section of Bloodland off limits.

Thirty-one years passed, and, in 1974, three soldiers suffered being taken captive by ghosts and forced to drink through a straw. These accounts were in the local paper; however, now there is no existence or proof the articles or the event ever happened—just another urban legend growing out of Bloodland's disappearance. The firing range where the town once stood is named Bloodland Range Control.

Other ghost sightings are of an older uniformed man who speaks to people and then fades from sight, and soldiers are seen patrolling who become shadow figures and disappear.

A touching tale is of the little girl who died at the Partridge Preschool. The four-year-old's favorite swing will move on its own accord even when no wind is present and the other swings remain perfectly still. If you rattle the doorknobs in the school and wait, she will rattle the knobs in answer. Music is heard coming from a classroom closest to the swing outside. The music may be played very loud or suddenly stop. She seems to have favorite toys she likes placed in particular spots and will move them if they are not arranged properly. There is no known proof of the death of a child, so who sits in the swing and fusses over "her" toys?

CHAPTER 8

SPRINGFIELD, MISSOURI

About 150 years ago, a man named John Polk Campbell took a liking to a spot in the Missouri Ozarks and carved his initials in a tree near a deep spring. That tree and the natural well beside it made up the foundation for the Queen City of the Ozarks, Springfield, Missouri. Delaware and Kickapoo Indians originally lived in the area.

Richard Grosenbaugh's website tells of Springfield and Green County's history. He notes Campbell returned to the spring in March 1830 to settle here with his family and found William Fulbright living in the area. Soon others moved to the area then known as Fulbright and Campbell Springs. In 1835, the settlement had grown around the natural well to be officially named Springfield. The town was incorporated in 1838 and grew steadily until the Civil War.

The Cherokee were removed forcibly from their land by the government and marched across the country into Indian Territory. The Trail of Tears went through the Springfield area on what was called the Old Wire Road, also called the Military Road; it was the connection between Springfield and the garrison at Fort Smith, Arkansas. The Butterfield Overland Stage used the road as passage to California. Telegraph lines were later strung along the road, giving it the nickname Telegraph or Wire Road. It can still be accessed in the Wilson's Creek National Battlefield. Part of the Old Wire Road became Route 66.

Colonel Franz Sigel and his Union troops marched into Springfield Square on June 24, 1861. General Sterling Price seized control of the square in August.

In August 1861, southwest of the city near Wilson's Creek, General Nathaniel Lyon and General Price confronted each other. This was the first major battle west of the Mississippi and one of the bloodiest of the war. The result was the death of 1,317 Union and 1,230 Confederate soldiers. General Lyon fell in battle and died later as the field hospital. Lyon was the first Union general to die in the war. The Confederates claimed victory, but their progress toward St. Louis was blocked.

Wilson's Creek was the first battle within the Springfield area, actually taking place outside what is now the city of Republic; the second took place on January 8, 1863, when General John S. Marmaduke advanced toward Town Square.

Union forces from Major Charles Zagonyi's charge occupied Springfield in October 25, 1861. This was called the First Battle of Springfield. Some of the fighting was house to house and hand to hand, which was rare. After leaving in November, they retook the city in February. Springfield was ruled by military between 1861 and 1865.

The Wild West era began after the Civil War. Springfield helped in giving rise to the legendary exploits of that time. In July 1865, the nation's first-

Vintage postcard of Wild Bill Hickok. *Courtesy of Janice Tremeear.*

recorded shootout occurred in the downtown square between Wild Bill Hickok and Davis Tutt Jr. Tutt claimed Hickok owed him money from a poker game in the Kerr Saloon on Park Central Square and took his pocket watch as payment. Tutt would wear the watch in public to show that Wild Bill didn't pay his debts. On July 22, Tutt fired a shot at Hickok from seventy-five yards away, barely missing his head.

Hickok fired back, hitting Tutt in the heart. The marksmanship of Hickok became national news and made him famous worldwide. Tutt was standing approximately on the site of what is now the old Herr's building.

Another event took place on Springfield's downtown square, giving rise to tales of the entire area being home to ghosts.

On April 14, 1906, Will Allen, Horace Duncan and Fred Coker sat in jail; the African Americans were falsely accused of sexually assaulting Mina Edwards, a white woman. A rabble broke into the jail, dragging the men to the town square, where they were hanged and burned without trial. The mob of two thousand hanged the three innocent men from the Gottfried Tower, where a replica of the Statue of Liberty stood.

Ask any college-age waiter if the downtown square is haunted, and they will answer yes. Springfield once boasted twenty theaters, although most are gone now. The old Fox Theater sat on the northeast corner of

Vintage postcard of Springfield Square on Route 66 facing west to College Street. *Courtesy of Janice Tremeear.*

the square and is said to be on top of Giboney Cave, which is haunted by a young couple who entered and never returned, along with soldiers from the world wars, Native Americans and other explorers who never came back from a spelunking adventure. Shadow figures are seen at the cave's main entrance in Doling Park. The cave runs beneath the town square with hidden entrances in some of the buildings, according to legends. The old theater is now a church, and cold spots are reported. The old J.C. Penney building and Barth's were in the same corner, and that section is considered very haunted. Barth's has stories of orbs inside the building and a young boy wearing a Boy Scout uniform.

Gillioz Theater

M.E. Gillioz of Monett, Missouri, built a lovely theater on St. Louis Street in Springfield. It opened October 11, 1926. One of the features was a pipe organ to be used for live performances and silent movies.

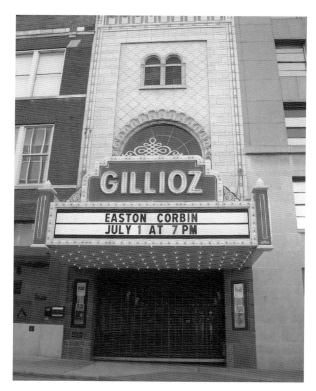

Gillioz Theater in downtown Springfield on Old Route 66, which is now St. Louis Street. *Courtesy of Dean Pestana.*

Ghosts along the Mother Road

Sitting on Route 66, as the Mother Road enters the downtown section of Springfield, the Gillioz has a beautiful façade and a sad story of the projectionist who died during a movie. The theater owner stepped over him to change the reel, leaving the poor man on the floor.

One ghost in the building is a boy about ten years old vanishing into a wall. Famous personalities who visited the Gillioz include Elvis, Ronald and Nancy Reagan and Mrs. Grover Cleveland Alexander.

LANDERS THEATER

Two streets south of the Gillioz is the magnificent Landers Theater. Built in 1909, it is the oldest civic theater in operation in Missouri and the largest. Almost all of its structural framing is wood, unusual in its time, but the owner, Landers, was in the lumber business. Bonded steel is used along with masonry assemblies. The front façade is of Missouri limestone piers, terra cotta cornices, cartouches, quoins and parapets. Brick fills in between these elements; the design is baroque and Renaissance and reflects Napoleon III's influence.

There are even decorative elements resembling screaming devils on the ornate four-story building. A large stage—the second largest in the state—was built for live performances.

Part of the great Orpheum circuit, the Landers featured the Weaver Brothers and Elviry before they went into movies. Other famous performers who graced the stage were George Cohan, Lon Chaney, John Philip Sousa, Lillian Russell, Fanny Brice, Kathleen Turner and Tess Harper.

On December 17, 1920, a fire began when an explosion from a boiler spread to the coal bins. It raged through the Landers Theater. An asbestos curtain helped keep the theater from being destroyed. Ensley Barbour rebuilt it in 1922. When *The Jazz Singer* debuted in 1927, the Landers became the thirty-fifth theater to convert to sound motion pictures.

When I was in the Landers, the story we were told of the ghosts in the balcony were connected to the fire. The grand Landers has two balconies; the second was reserved for the African American community back in the twenties when segregation was in force. It was here, in the highest balcony, where the mother dropped her child during the panic that broke out from the fire.

Another version of the mother and baby story is that during a performance the mother accidentally let go of her child and the baby fell to its death. This is a residual scene that plays over and over, and many have reported witnessing

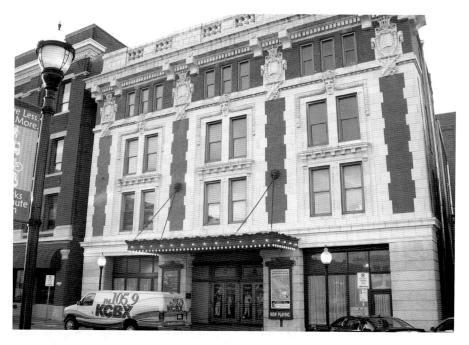

Landers Theater on Walnut Street in downtown Springfield, Missouri. *Courtesy of Dean Pestana.*

this event. The cries of the baby and mother are heard. Performers see the baby fall.

It is said a man was knifed to death in the second balcony. A green phosphorescent haze normally is spotted in the second balcony, but reports are that it can be found anywhere in the building. This green orb is about five feet tall and is accompanied by a twenty-degree drop in temperature.

During the fire a janitor is said to have perished. He has been seen in the balcony, watching the actors onstage. When at the theater, I saw the scorched brick backstage where the spiral staircase used to lead up to the burned-out dressing rooms.

The fourth floor served as apartments for touring actors and actresses. On this floor people outside see a figure in the windows peering from behind a curtain in what is now a costume room. Some say it is of a male while other tales indicate a female; a common factor is the Elizabethan clothing and long blonde hair of the specter staring out at those on the street below. This apparition is only seen from the outside and has not been spotted while inside the building.

Ghosts along the Mother Road

The viewing box seats from the first balcony of Landers Theater. *Courtesy of Janice Tremeear.*

A male apparition has been spotted in the middle of the auditorium; people are tapped or shoved; and equipment turns itself on or off or becomes unplugged on its own.

Spotlights turn off and on; whispers are heard in the lobby; and the spirits of two secretaries toss objects, supposedly. Even a phantom dog has been reported.

Legend says a stagehand hanged himself from rafters over the stage and no one noticed him for three performances. There are now complaints of lights that won't shut off, disembodied footsteps on the overhead catwalks and feelings of being watched.

I was told by one of the workers that he heard the sound of a woman's high heels walking across the stage floor above him one night when no one else was in the theater. Shadows are seen in the balconies and the stage. Hammering sounds are heard.

A black void is seen. The mass blocks all light and completely covers anything behind. The void can be found anywhere in the theater, even outside in the small alley between Landers and the Vandervort Hotel.

WALNUT STREET INN

Walnut Street is a mile of historic homes and buildings and sits one street south of Route 66. The Landers Theater is on Walnut. So is the Walnut Street Inn, a three-story Victorian home built in the 1890s by Charles McMann. The original oak floors are still in excellent condition. Leaded glass windows and original light fixtures are still pristine. Even the west-side carriage entrance is in use. The carriage house was divided into guestrooms in 1992.

Guests in the Rosen Room say a ghostly presence is there. A gentleman reported in 1998 that he saw a female sitting at a table in his room. When he said this was his room, the female answered, saying the room was indeed her room. She then disappeared. The staff says she may have been in her seventies when she died and think she has chosen to stay and watch over the inn.

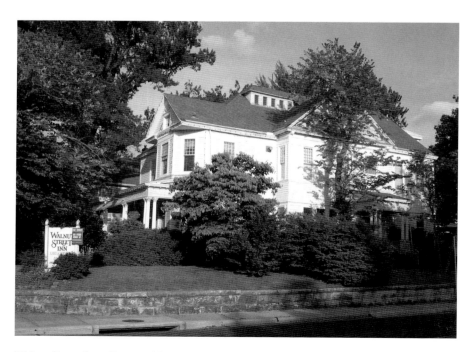

Walnut Street Inn. *Courtesy of Dean Pestana.*

Pythian Castle

Springfield has its own castle. The structure sits well hidden behind Evangel College. Driving along Glenstone one would never know the castle existed from the view near the street. An expanded asphalt lane replaces the narrow gravel drive leading to the castle, as we discovered when we visited for a tour and history of the castle.

The building was designed to resemble a castle reflecting the theme of the Knights of Pythias, a male secret society started during the Civil War. Built from 1911 to 1913 on fifty-three acres, the cost to build the castle was $150,000. The foundation is of Carthage stone, a hard variety of limestone quarried in the Ozarks. A steel framework supports the building with concrete floors, stairways and ceilings. Pyrobar blocks make up the interior walls. At the time the society called it a lodge. The Knights of Pythias built thousands of these lodges to house the widows, orphaned children and the aged of the order.

Dean and I met with Tim Piland, the castle tour guide, for a most interesting afternoon.

The castle houses thirty-six rooms and a second-floor theater seating 355 people with ticket booth, seats, upper projection and lighting room plus changing rooms backstage; the theater was the first in Springfield to show silent films. Funerals were held here, along with church services for the orphans. It was in this large room that the Booth Brothers photographed the large handprint on a windowsill on the east side of the room.

Thirty stairs lead up to the front door. The main floor has a foyer, meeting room, ballroom, dining hall and sitting parlors. The basement houses a gymnasium along with cells used by the military. One room is said to have belonged to a Japanese man who was the cook. His paintings decorate the wall.

Besides the theater on the second floor are dormitories for the children, who lived there when the building was an orphanage, and bedrooms for adults. According to Tim, the boys were segregated to the right side of the building, girls to the left. The children accessed the kitchen via the dual staircases from the dorms on the second floor. They sat on opposite sides of the kitchen and were not allowed to speak to one another. One of the surviving orphans of the era says a boy ran away from the home due to loneliness. He wasn't allowed to talk with his sister.

A powerhouse and carriage house were also part of the property, along with the boiler and laundry.

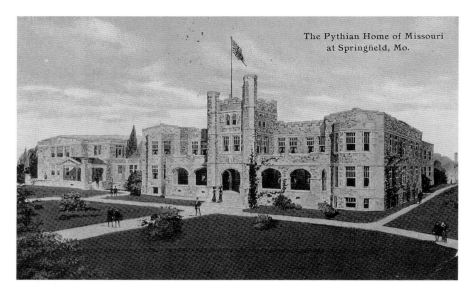

Vintage postcard of Pythian Castle in Springfield, Missouri. *Courtesy of Janice Tremeear.*

Records show 105 deaths occurred in the facility; 2 of these were children. There are no public accounts of military deaths; those records are sealed.

It became the O'Reilly General Hospital when taken over via immediate possession by the U.S. military and was used for a service club for enlisted men in World War II. Renamed the Enlisted Mens' Service Club, the castle was used for rehabilitation of injured U.S. soldiers and for entertainment.

A library and arts and crafts section was included. The theater hosted big bands for the USO and famous movie stars. Bob Hope, Cab Calloway, Tommy Dorsey, Benny Goodman and Gloria Stuart (the elderly Rose in *Titanic*) performed here.

German POWs were held in the basement, according to accounts. A cell in the basement has iron bars; they were labeled "hostile," and any POW who died was left in the steam tunnel.

There is talk that the prisoners may have been tortured. One room in the basement bears markings curiously resembling bullet holes. Were the prisoners shot? Would someone risk ricochet from firing a weapon in the small room?

After the war, the castle was used as a reserve center before becoming storage. The building served as a hospital for four years and eleven months before being leased to OCAC (Ozarks Area Community Action Corporation).

After 1993, a couple tried to maintain the building, but the cost of upkeep proved too much for them, and they moved out.

Pythian Castle gained a new lease on life when the current owner, Tamara Finocchiao, bought the building and began hosting weddings, murder mystery dinners and ghost hunts. Tamara's quest to preserve the castle has not been an easy one. She's struggled to meet city requirements and now has the castle on the National Register of Historic Places. We met Tamara and found her to have a genuine love for the castle and its restoration. Like Tim, she is very protective of the ghosts inhabiting the place, and neither of them believes the majority of the spirits are malevolent—except possibly the one in the tunnel area.

Voices of a man and woman having a conversation are heard; orbs are captured on film, voices on recordings; people feel lightheaded and nauseated in the basement; batteries are constantly draining and light bulbs blow; temperature changes; and doors closing and furniture moving are reported. Sounds of children, women and even men weeping are heard; strange mists form out of nowhere; and a ghost cat has been heard running upstairs, meowing. A child's voice has been captured during an EVP session.

In 2007, Philip and Christopher Booth released a documentary filmed in St. Louis on Zombie Road and also Pythian Castle.

While onsite they filmed a man-sized shadow following them through the tunnel. Noises were heard behind them, pounding on the pipes as if water was flowing, but the pipes are not connected as both photos and the video proved. I've been in the tunnel; Dean and I checked the pipes inside the tunnel—large sections are missing, as evident in the photo on the next page. It's impossible for any substance to be moving through them.

It has been thought a ghost named Jeff resides in the castle. But when that name is used, the fire alarms go off, as if someone is trying to say the name is wrong. Tamara's research has uncovered a man who suffered from throat cancer shot himself onsite. His name was Jess. Other spirits said to haunt the castle are Ben and A.J. People come onto the property asking Tamara if she's met either of these two male spirits.

Tim is a skeptic, but his first night in the castle proved a restless one as a hand gripped his arm and awakened him. He believed it was M.J., Tamara's mother, who told him to "get up. The dog is on the roof." Tamara and her mother were not in the castle at the time, but one of the greyhounds was stuck outside on a small roof.

He's heard dragging sounds in the basement and shuffling feet on the other side of a locked door; voices from the kitchen and a childlike "yoo hoo"; and sounds of glass breaking, even though nothing is there when it's

Tunnel leading from Pythian Castle to former laundry facility. The orphaned girls carried laundry through this tunnel during the winter months. It was here the Booth Brothers caught the apparition of a shadow figure following them down the tunnel while filming *Children of the Grave. Courtesy of Dean Pestana.*

been investigated. He says humming is heard, as well as sounds of objects being moved around, and a frigid cold is felt in the theater.

In the boiler room at the entrance to the tunnel, Tim was giving a tour and heard footsteps coming up behind him. The tour group was in front of him. During a wedding in the castle, Tim was down the next level, in the kitchen area of the basement getting supplies. On the other side of a locked set of double doors he heard a shuffling gait. Going through the castle into the basement from the other side, he searched and found the room to be empty. Going back to the kitchen, he heard the shuffling again. This time he called out, telling whoever was on the other side to "stop it." The gait ceased.

Ghosts along the Mother Road

On another occasion, Tim was playing poker with his cousins. Doors within the castle began to open and close, followed by the sounds of crates dragging across the basement floor.

Tamara walked beneath a tarp during renovations and encountered something solid, yet no one was on the other side. A police officer on a tour of the castle saw a military officer standing in the boy's dorm.

During renovations on the bowling alley in the basement, a worker decided to spend the night in the basement. He tried to open a recliner, but the broken chair barely budged. Giving up, he slept on a couch nearby. In the middle of the night the recliner opened by itself.

Jeanna Barker, a member of Route 66 PAL attended a tour and was standing on the stage. No one was nearby when she felt a man's hands on her shoulders.

In the tower room, while filming, the Booth Brothers captured the EVP (electronic voice phenomena) of something saying, "You Bastards." The

The tower room inside Pythian Castle. Janice stands in the room where the Booth Brothers captured an EVP (electronic voice phenomena) on a recording during the filming of *Children of the Grave*. Courtesy of Dean Pestana.

tower room has a reputation of being the site for child molestation. Tamara's dogs refuse to enter the room.

Tim recounted his stories as he led us through the beautiful rooms of the castle. New accounts popped into his mind, and as I hurried to write the tales down I caught a male's bemused chuckle. Perhaps Jess was enjoying hearing of his exploits.

Maple Park Cemetery

The final resting place of Dave Tutt is a beautiful, pleasant spot. It opened in 1876 and contains a gazebo, winding paths and grand old maples. The gazebo has been restored and the entire place carries a Victorian air.

I've heard from a few people that they've seen shadow figures inside the cemetery at night as they drive past. A little girl plays in the cemetery. She appears to be aware of her surroundings and the people around her. Figures are seen near a mausoleum; the ghostly people vanish when approached. Music is heard at the gazebo, and orbs hover inside the graveyard at night.

Maple Park Cemetery. *Courtesy of Dean Pestana.*

MSU

Missouri State University was founded in 1905. It was known as the Fourth District Normal School. The first class in June 11, 1906, held off campus, consisted of 543 students.

Academic Hall was the first building on campus; its cornerstone was laid on August 10, 1907, and the building is now named after William T. Carrington, the first school president.

There are many haunted sites on campus. Tammy Preston and Charlene Wells both attended the university and have several stories—some odd, some chilling and one that must be included simply for the humorous quality of the tale.

These are reports you won't find searching the Web, but the students are well aware of the legends of MSU.

As this story goes, a young woman was studying for her finals late one night. She started to feel odd, with the hairs on the back of her neck standing up. She saw a young man coming toward her. He was wet. She blinked—this could not be right. She looked again and the man was gone. She continued to study—or she tried to study—but felt she was being watched. She couldn't focus and decided to leave.

While walking toward the elevator, she saw wet footprints on the floor next to the elevator. According to Tammy, "the creepy feeling got even stronger," and she avoided taking the elevator and becoming stuck inside with a stalker. Running down the stairs, she failed to see the wet footprints in the stairwell.

She ran out of the building and toward the fountain. Near the fountain, hands shoved her. She lurched forward and hit the side of the fountain with her head. When she awoke several minutes later, another student was performing mouth-to-mouth on her. The student had witnessed her fall and rushed to help before she could drown.

After the woman sat up, two handprints were on the back of her shirt where she had been shoved. No one was spotted near her.

After the incident circulated the school grounds, an older teacher related this information:

A student was studying late in the Duane Meyer library for finals. The student worked in the library, and afterward he began his study once the books were placed back on the shelves. It was quiet and he needed a good grade in math to enter medical school. He was nearly failing algebra and geometry, and his test was the next morning. He stayed up far into the night until his vision began to fail. Deciding to get some sleep, he left the library.

Staggering toward his dorm he slipped on a wet brick by the fountain. He fell, hitting his head on the side of fountain, and slid into the water unconscious. He didn't wake up and no one saw him. The poor boy drowned.

McDonald Arena

Tammy tells another unusual tale, this time about McDonald Arena. Opened in 1940, the facility was state of the art at the time. It had a basketball court and stadium seating, but that wasn't all. Above the seats is an indoor track encircling the top of the building. The track became a popular place for students to hide when they wanted to sneak extra game time on the court or use the weights inside the men's locker room. The security guards on campus made it a routine to stop and check the track to see if anyone was lingering.

One night, one of the newer security guards was checking the locker room when he received a call on his radio that a guard outside could see the shadow of someone jogging on the track through the windows running around the top of the building.

The new guard radioed back. He had just been there and the place was empty. Yet the older guard insisted a jogger was on the track. Without turning on the main lights, the new guard turned on his flashlight and went back to the auditorium. As he neared, he heard the steady sound of tennis shoes on the track. He waited in the shadows until the footfalls neared him. He jumped out and flashed his light at the sound of the runner. But no one was there. He heard the jogger run past him—except the track was empty. He felt as if the older guard was playing a joke on him. After he went down to speak to the older guard, the man who saw the runner insisted he was not playing a joke. He swore he saw someone running upstairs.

The young guard dismissed the event and finished out his shift. Two days later, when he returned to work, the other guards were talking about a nighttime runner they couldn't catch. The new guard felt the joke was being carried too far, and too many people were becoming involved. He made a suggestion that one the guards hide in the back alcove by the track; this would prevent the runner from escaping detection. Two more guards would then come up the stairs with one on each side to trap the runner.

The younger guard hid behind equipment bags and waited. He was about to fall asleep when he heard the jogger. He waited with outstretched arms, his fingertips brushing both sides of the wall. No one could get past him tonight.

The other guards turned on their flashlights, aimed toward the younger man. As the lights crossed, no one was there but the young guard. Downstairs

the fourth guard could still hear the runner. He could see the shadow of the man as he passed the windows. There was no explanation, and some say it's merely the wind.

People still report witnessing a jogger in the upper section of the arena. People outside see his shadow at night through the windows. There are two possibilities to why the runner is on the track: One report is the young man committed suicide inside the building. The other story is a jogger had a heart attack and died while he was on the track.

Hill Hall Pool

Hill Hall Pool was the athletics building and a marvel of its age because it was the first indoor pool in the city of Springfield. Like the pool in *It's a Wonderful Life*, the floor opens to reveal the pool beneath. On special days the pool opened to the community, and children could swim. With these large parties the university established bonds with the town. Hill Hall has since become part of the art annex. The pool is closed, and the kilns for the pottery classes are located where the pool existed. It's common for the art students to talk about smelling the chlorine from the pool. The assumption is the smell has permeated the building even though the pool was sealed and the walls painted over several times. It's possible the heat of the kilns brings out the chlorine odor.

However, there is no explanation for laughing and giggling of happy children or the wet footprints that appear several times during the year, always at the times the community events had been held.

Freudenberger Residence Hall

Freudenberger Residence Hall was built in 1959 and named after Norman Freudenberger, a professor of Latin for forty-five years at MSU and head of the foreign language department for thirty-six.

Starting on the fifth floor, residents in room 566 complain of very loud noises above. But there are only five floors to Freddy House. There are no air-conditioning or heating units above and nothing to account for the loud thumping and music. If rooms were above, it would be 666.

In room 557 a few years ago, girls collected shot glasses of the special places they had been. It had grown to be quite extensive, and, in an effort to cut down on the clutter, the girls got permission to build shelves to display the glasses. Very proud of their work, the girls went down the hall to ask

friends to come see their arrangement. When they came back into the room, the shelves were empty and the shot glasses stacked neatly in a pyramid in the middle of the floor. A dorm mom is said to haunt the fifth floor as well.

During the Battle of Wilson's Creek, smaller skirmishes occurred around the area. One of these happened on the Quad between the back of Carrington Hall and the new Strong Hall. After the fighting ended this area became a makeshift hospital. During the construction of the two buildings, several cannon balls were found. On warm summer nights, it's said you can hear Brigadier General Lyon calling out to his troops trying to rally them to his support. Evidently the brigadier general is still trying to win a war that is long over.

Kentwood Arms

More campus tales from Charlene and Tammy include ones about Kentwood Arms, which was purchased by MSU to be a residence hall for married students with families. Many people have heard loud ragtime piano music played in the basement; no piano exists in the basement. No one lived in the basement, and no one was playing a radio or any type of music at the time of the first report. Once families with children began living in the building, the children would hear an adult male telling them to "Scram!" and "You should know better than to be hanging around here." There is never anyone seen by the children when the voice is heard. A custodian said when the hotel was built that it was a speakeasy in the twenties, with women available for the men who came to drink and gamble.

One of the gamblers liked to play the piano before he played cards and was a fan of Scott Joplin. He fell in love with one of the girls and tried to buy her freedom. The owner of the establishment refused to let her go and insisted she would make him more money with her beauty than the gambler could ever win.

A fight broke out between them and the mobster pulled a gun, shooting the young gambler. He died on the spot.

The custodian said several people talked about hearing the music and occasionally a gunshot. The young man has stayed until his true love joins him.

MSU Squirrels

Tammy Preston's tale of the "Killer Squirrels" is presented here in its entirety:

The legend is that there was a grounds keeper when the school was actually the Missouri State Teachers College that would feed part of his sandwich to the squirrels every day. One Christmas, it was very snowy. The snow had come early that year, so the squirrels were starving because they hadn't been able to gather enough nuts. The Grounds keeper was out hanging Christmas light around the large cedar tree in the quad in front of Carrington Hall.

One of the squirrels was so hungry, that he dashed out of the branches and began to rummage in the Groundskeeper's pockets for the sandwich. The squirrel running around the man's pants startled him so much that he leaned back on the ladders. The ladder fell 30 ft and the Grounds keeper died of a broken neck. The squirrel lived. His fall was cushioned not only by the man, but also by the sandwich.

The story doesn't end here though. It is said that the other squirrels were so angry that their food source was dead that they chased the offending squirrel off of the campus and into National Street. While the squirrel lived, it was so traumatized by the oncoming traffic that its fur turned white.

Now any time a white squirrel is seen on campus, the other squirrels will immediately begin chasing it until it is in the street again.

There is another version of the story where the white squirrel was a little girl squirrel. It was so beautiful that the grounds keeper could not help but to fall in love with her. He would constantly pet her and give her treats. He even went so far as to make a special squirrel house for her to live in. The other squirrels got so jealous that when the groundskeeper was on the ladder, they surged around the bottom and tipped the ladder over, killing the groundskeeper. The squirrels then chased the girl squirrel off campus. Now any time her children and great grand children try to come on campus, the other squirrels immediately chase them away.

To add to the tale of the Killer Squirrels is the memorial plaque set in the quad, in memory of the groundskeeper who died in service to the university.

MISSOURI'S HAUNTED ROUTE 66

The Phelps Grove Bride

Submitted by Tammy Preston:

While the Phelps Grove Park is not actually a part of the MSU campus, it is close enough that students have heard the story of this poor bride since the school started. Shortly after the city of Springfield was incorporated, a young girl married the man of her dreams. By all accounts the young man loved her with every breath took. At their wedding reception, his friends offered the young man drinks.

Not having drunk much before the strong liquor quickly took hold of him. Before long, the young bride became embarrassed by his loud and belligerent attitude. Knowing it was the drink she tried to persuade him to leave. It took a few more drinks and he finally left. As they were leaving, the bride looked back at the party. The groom thought that she looked back at another man. He began to yell and accuse her of improper actions. The girl tried to reassure him, but the more she tried, the angrier he got. The yelling frightened the horse on their buggy. The horse ran. The drunken groom lost the reins. The bridge over the culvert was narrow and the horse dodged to run down the embankment instead of going over the bridge. The buggy hit a rock at the corner of the bridge. The bride was thrown from the buggy and landed under the bridge with the buggy on top of her. The horse tore loose from the buggy and ran off. When the groom shook off the fall and the stupor from the liquor, he went to his bride. The fall had broken her neck. The young man was overcome with grief and shame. He went to the top of the bridge. While it's not tall, the young man tied his tie to the bridge very tightly and jumped forward. The forward momentum was enough to break his neck as he fell backwards. Now, during the June wedding season there are reports of seeing a young man standing on the bridge and jumping.

There is a second version of the story where the young man is so convinced of his bride's infidelity that he leaves her. When he doesn't return in a few days, she starts to look for him. She never found him. After a year of pining for the groom, she dressed in her wedding gown and took the horse and buggy back to the park. She had never taken the wedding flowers off of their buggy, so the dead flowers still decorated the wooden frame. Then she tied a rope to the bridge and put the other end around her neck. The young bride threw a rock at the horse. It startled the animal and he ran. The horse kept running, but the rope pulled the woman off, snapping her neck. Now, people say in June they see the bride standing by the bridge with a rope around her neck.

Ghosts along the Mother Road

Springfield National Cemetery. A mist was captured by Pat's camera after she spoke to the soldiers buried here. *Courtesy of Pat Brown Bailey.*

SPRINGFIELD NATIONAL CEMETERY

My dad is buried at the Springfield National Cemetery. He shares the eighteen acres with soldiers, both North and South, from the Civil War and other veterans. The cemetery was established in 1867 and is on the National Register of Historic Places. Orbs are reported at twilight; residual spirits of soldiers from the Civil War are seen, along with a World War II navy man.

Pat Brown Bailey treated herself to a cross-country road trip down Route 66 for her birthday. She stopped in Springfield. At the National Cemetery she took a few photos; here's one with an anomaly and her comments: "No anomalies showed up until I spoke a few harsh words to the Yankees. Check out the right side of the photo."

WILSON'S CREEK NATIONAL BATTLEFIELD

In Southern history, the event is called the Battle of Oak Hills. Fought at Wilson's Creek ten miles south of Springfield, the battle was a victory for the Confederacy. It was one of the bloodiest battles in the history of the Civil War with approximately 1,317 killed by the North and 1,222 killed by the South. No one knows the number who died from injuries and wounds from the battle. History records the Battle of Wilson's Creek as the first major battle west of the Mississippi River. General Nathaniel Lyon was killed in battle. A marker has been erected on the spot where he it's believed he fell from his horse.

A part of the National Park Service, the battle site is kept in excellent shape. New relics are being dug from the soil. Residual haunting is said to occur

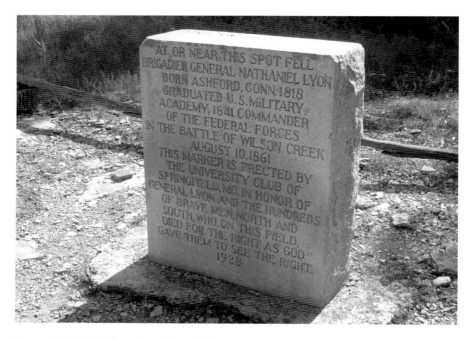

General Nathaniel Lyon's marker at Wilson's Creek National Battlefield. *Courtesy of Janice Tremeear.*

throughout the park and in the surrounding area. Cannons and gunshots are heard; ghosts of Confederate soldiers are seen; and cold spots and soldiers walking and talking in the woods at night are experienced. The nearby town of Republic has a neighborhood where soldiers are reported hiding behind homes. Some of the homeowners experience ghosts and shadow figures. They feel watched, and pets are afraid to enter certain rooms in the homes. A burning odor is noticed. Children are touched while sleeping, and voices are heard in unoccupied rooms via baby monitors.

CHAPTER 9
BUFFALO, MISSOURI

Rack It Pool Hall

Currently owned by Bill and Chris Bryant, the Rack It Pool Hall began as two separate buildings. It has previously been a newspaper office and a bar.

Customers have witnessed unusual activity in the bar. A whistle is heard, followed by "Ha Ha"; a heavy object is moved and doors slam repeatedly in the back hall; feelings of not being alone are felt when in one of the back rooms; shadows are seen near the bathrooms; and a child's voice is heard.

Pictures disappear from the ladies room, although Chris isn't certain whether this is paranormal or the result of overzealous bar patrons.

Tiny plastic objects are thrown at customers. One worker was standing at the bar, facing the room with pool tables and a small stage. He made a derogatory remark about the ghost. The second room was completely empty, and a small piece of plastic sailed out of the room and struck the man in the chest.

Another man on a separate occasion was playing pool at the table in front of the bar. He was standing next to a supporting pole with a tin beer sign nailed to it. Again, the men were joking about the ghost. From the wall on the other side of the pool table came another plastic object, flying at the customer, missing him by inches and striking the tin sign.

A legend persists from before Bill and Chris bought the buildings. The pool hall was a bar before they purchased the buildings. The tale is of two men playing pool in the room with the stage. They were poking fun at the

ghost, and a pool ball lifted off the table and flew out through a front window. The wooden ball was found outside in the middle of the street.

Buffalo boasts a red brick building that is the oldest one standing from before the Civil War. There are other reports of hauntings in the town square, just a few feet from Rack It.

Route 66 PAL spent the night inside Rack It this year. Andrew and I observed fingertip-size lights moving back and forth over the pool tables and once they appeared to be checking out our cameras. Audible voices were heard and recorded.

Dean gave a whistle and the tune was mimicked on recordings. A white apparition was observed moving into the small kitchen area. Several Class A (voices very clear and easily understood) and Class B (voices fairly clear and may be audible without the use of headphones) EVPs were captured. After our visit, thumping began on the wall from the next building, and people have come forth with more tales of ghosts in the county.

CHAPTER 10
CARTHAGE, MISSOURI

The ghost of a woman and two men haunts the Carthage Courthouse. The female is on the second floor, one male is in the attic and the other in the basement. Paranormal activity occurs on the square with shadow figures seen in homes nearby. Soldiers are seen in the woods and the countryside.

GRAND AVENUE BED AND BREAKFAST

This Queen Anne Victorian home was built in 1893 with elegant touches, including a variety of hardwood moldings, stained-glass windows and a sweeping grand staircase. A male ghost haunts the dining room and parlor. The smell of cigars fills these rooms when he's present. Other ghosts are said to be in the historic home.

KENDRICK HOUSE

This home survived the Civil War battle that raged just a few feet away. Sinnet and Elizabeth Rankin arrived in Jasper County from Ohio in 1842 and put slaves to work building the home in 1849. Most neighbors lived in one-room log houses; the brick two-story home was a mansion by the standards of the day. The home and 635 acres of land were sold to Thomas Dawson in 1856.

Vintage postcard of the city park in Carthage, Missouri. *Courtesy of Janice Tremeear.*

Dawson rented the mansion to William Kendrick. Kendrick was in ill health and appointed Joshua Draper Palmer Kendrick as overseer of the home. William died on January 19, 1849, in Arkansas.

The 1860 Slave Census of Newton County, Missouri, lists a thirty-seven-year-old black female and six black children age twelve, ten, seven, six, four and six months owned by William Kendrick.

The Kendricks maintained a neutral stance through the war—probably as a means of self-preservation—and kept their doors open to both fighters and followers of both North and South. The house survived the wartime depredations that resulted in destruction of most of the residences of the area.

The home started in 1849 and completed in 1854 was made by slave labor. Each brick is concave on one side, so it could hold more mortar.

The wood and large timbers came from the farm. The foundation is made of rough Carthage stone, faced with four-inch-thick slabs of smoothed sandstone.

Supports through the center of the home are two huge trees, fastened with a shiplap joint. Each tree is about two feet in diameter and less than thirty feet long. The supports are oak, most with bark still clinging on them, resting on piers of rough Carthage stone. The slave quarters were of the same type of brick that was used to build the house and cistern.

Ghosts along the Mother Road

The place originally had a two-story veranda on the front. From this location one night in October 1863, the Kendrick family from the second deck of the porch watched Carthage as it went up in flames, viewing burning carriages and people on the horizon.

Later, the soldiers burned the porch. The veranda has never been replaced. The original sandstone steps are at the front doors today.

A trapdoor in the living room leads to the tunnel used as part of the Underground Railroad. Two large doors sit in the wall of the living room to allow horses to be brought inside. Hoof prints exist on the threshold where soldiers occupying the home during the war brought their mounts indoors to hide them form the opposing army.

The custom before the war was for a brick house to be built with a frame addition running to the rear for uses as a dining room, kitchen and slave quarters. The Kendrick house is built in this style. About 1908, the old frame portion was torn away and a more modern addition substituted. In 1954, this portion was torn away and still another wood addition erected.

Two battles were fought in Carthage, in 1861 and 1864. Slaves were murdered on the property with one woman hanged in the back yard.

Whispers are heard in the house; teacups are moved. The odor of horse manure was apparent inside the home during our visit. Cigar smoke can

Kendrick Place in Carthage, Missouri. *Courtesy of Janice Tremeear.*

Vintage postcard of Route 66 featuring Coral Court Motel in St. Louis and Bob Miller's Restaurant in Joplin, Missouri. *Courtesy of Janice Tremeear.*

be noticed while on the staircase. Lilac perfume, the fragrance of choice of Mrs. Kendrick, is smelled in the parlor.

Children's clothes, laid out on a bed in historic display, are tossed on the floor if they aren't laid in a certain manner. Footsteps are heard; children have been seen playing in the yard by employees of a trucking company next door. A golden light is seen moving through the house. One of the lights in an upstairs bedroom has been reported to turn on when all power to the house is off.

Charlene, Tammy Preston and I have been inside the home and walked the grounds. We've witnessed a bed in one of the upstairs rooms appear to move as if someone were sleeping there. Faces are captured in windows and soldiers seen in the battlefield next door. A musket ball was found inside a car parked out in front of the home. People are touched and clothes tugged; orbs and mist are captured on film; and voices are heard in the slave quarters.

The home is thought to contain as many as eight spirits. The ghosts of several soldiers and slaves roam the ground outside. A woman in white is seen, and a rocking chair moves on its own.

CHAPTER 11
JOPLIN, MISSOURI

Joplin was once the lead and zinc capital of the world. Contrary to popular belief, the city was not named after Scott Joplin but Reverend Harris Joplin, founder of the first Methodist church in the city. Bonnie and Clyde and Blanche and Buck Barrow, lived in a hideout in Joplin for a few weeks. They robbed several businesses and escaped Joplin after a famous shootout where they killed two detectives. The ghosts of Bonnie and Clyde are said to haunt a number of Missouri sites, even though they were shot in Louisiana.

Joplin sits above a network of tunnels. Basements have openings into the mines, allowing the workers to come and go at will. Most tunnels are closed now.

Freeman Hospital

John W. Freeman donated the land where the first Freeman Hospital was built and opened in 1922. In 1975, the new Freeman Hospital opened its doors to the public. Evidence shows that the hospital may have been used as a church at one time. The hospital is currently unoccupied and used for storage.

A demonic presence is felt there, along with a sense of unease, dread and being afraid to be left alone. Maintenance workers refuse to go to the fourth floor. People become ill and are shoved; they have also heard unexplained noises and knocking. Batteries are quickly drained.

Peace Church Cemetery

The black shadow of a man roams the cemetery. He is Billy Cook, a hitchhiker who killed a family of five and a motorist. He vanishes as you approach him.

Some hear voices, see light weaving among the trees and hear whispers next to them. Some think their name is called or experience car trouble near the graveyard.

Bad man Bill Cook was raised with his siblings by their widowed father inside an empty mineshaft where he later abandoned the children. Cook was too much for foster parents to handle and was sent to the Missouri Penitentiary.

He was twenty-one when he began his killing spree. A two-week trip started after Christmas 1950 with the carjacking and murder of the driver. Billy drove around the state, kidnapping and torturing his victims before finally killing three adults and three children. He kidnapped nearly a dozen people, including a deputy sheriff. He attempted other killings and terrorized the southwestern Border States.

Rumors say he is buried outside the cemetery on unhallowed ground.

Prosperity School Bed and Breakfast

Prosperity Township, a two-fisted mining camp on the outskirts of Joplin, needed a school. A brick two-story building was put up, and classes were held there from 1907 to 1962. It held twelve hundred students in its day, but when the mines declined in the area so did the school. At the turn of the century the town was thriving and sometimes violent—now it is little more than a few houses. After the school closed, it sat vacant for thirty years.

Janet and Richard Roberts renovated the building into a bed and breakfast and have learned of a tale of a murder that took place in the 1950s in the building. So far no real evidence has surfaced to back up the tale, but guests report unusual activity, including voices and a dark figure of a man walking between the kitchen and front door.

Knocking on the door of overnight guests has been reported. Doors open as people near them; orbs are captured on film; dowsing rods have reacted to an unseen presence; something in the bell tower has made people uneasy; rustling has been heard; items have disappeared; and dogs have barked at unoccupied rooms. Lamps have dimmed and TVs have turned off and on. Footsteps are heard on the stairs and the hallways:

some sounds are of heavy boots or of ladies' high-heeled shoes. The pipes rattled as if they were metal, but the pipes are PVC. Voices are audible in the building when no one is there. Shadows move, appearing to watch the guests. Photos show odd black shapes. Music and giggling are heard.

Doors open and close. Odd lights are caught on film as well as what appear to be figures. Shadows the size of small children dart about—one is reported to be a six-year-old girl who died from falling downstairs while others are adults, two women and three men.

TAPS and Christopher Moon have visited the B&B, and so has Dan Terry.

Dan conducted an investigation, and one of the video clips shows a "flat topped orb" rising in front of the camera. Energy streaks snaked from a bedroom to the hall and back. Another clip has a gray shadow crossing the doorway with arms and legs moving in the mist. Upon slowing down the video, the four-foot-tall figure turns toward the camera, and "there was the face of a child with dark hair looking into the room as it passed!" Mumbles are heard as well as a little girl giggling on another recording.

Jesse James

Jesse was everywhere in Missouri. While he has haunted the Jesse James Farm and Museum in Kearney, Missouri, for over a century, he's sighted throughout the state.

Vintage postcard of Jesse James. *Courtesy of Janice Tremeear.*

Vintage postcard of Billy the Kid. *Courtesy of Janice Tremeear.*

Billy the Kid

This famous outlaw is seen riding his horse outside of Joplin, Missouri, and near the Missouri–Oklahoma border. He died in New Mexico.

JOPLIN SPOOK LIGHT

This light, which has appeared seemingly as a ball of fire for almost 140 years, varies in size from a fist up to a basketball.

It was witnessed as early as the Trail of Tears in 1863; however, the first published record was in 1881 in a publication called the *Ozark Spook Light*.

The Hornet Spooklight or Tri County Spooklight has been a paranormal enigma for more than a century. Appearing as an orange ball of light, it travels east to west along a four-mile gravel road, the Devil's Promenade, near area locals. The road is farther down than where the spooklight

appears. It was a rickety wooden bridge connecting to Spooklight Road. If anyone paced the bridge five times and asked for the devil to appear, he would answer three questions, grant three wishes or kill you.

A Quapaw Indian maiden fell in love with a young brave from the area. According to the oldest tale, her father would not allow her to marry the man, as he did not have a large enough dowry. They eloped but were chased by a party of warriors.

When the couple was close to being apprehended, they joined hands above the Spring River and leaped to their deaths. The light began to appear after this and was attributed to the spirits of the young lovers.

Some say it is an Indian chief. Some say the light was present when the first white man arrived at the beginning of the nineteenth century.

The light may be a miner who lost his wife and children to the Indians and is still searching the road for them. Or maybe it is a miner who got lost in the woods and his wife took up a lantern and set off to find him. When he failed to return the next night, she searched again and again until she died. Now her ghost travels the road with the lantern.

Chris Bryant told me of the time she went to see the Spook Light. The car she was in was behind others, all parked, waiting for the light to appear. When it did, it was large and moved toward them. It hovered above the car in front of them and bounced on the roof of a vehicle, scaring the man inside.

People say the light interacts with those who come to witness it.

BIBLIOGRAPHY

Alaspa, Bryan. *Ghosts of St. Louis: The Lemp Mansion and Other Eerie Tales*. Lancaster, PA: Schiffer Publishing, 2007.

Courtaway, Robbi. *Spirits of St. Louis: A Ghostly Guide to the Mound City's Unearthly Activities*. St. Louis: Virginia Publishing, 1999.

———. *Spirits of St. Louis II: The Return of the Gateway City Ghosts*. St. Louis: Virginia Publishing, 2002.

Curtis, C.H. Skip. *Birthplace of Route 66: Springfield, Mo*. Springfield, MO: Curtis Enterprises, 2001.

———. *The Missouri U.S. 66 Tour Book*. Springfield, MO: Curtis Enterprises, 1994.

Gilbert, Joan. *Missouri Ghosts, Second Edition*. Hallsville, MO: Mogho Books, 2001.

Golden, Dianne Halicki, and Ellen Robson. *Haunted Highway: The Spirits of Route 66*. Phoenix: Golden West Publishers, 1999.

Knowles, Drew. *Route 66 Adventure Handbook: Expanded Third Edition*. Route 66 Series. Santa Monica, CA: Santa Monica Press, 2006.

LaChance, Steven. *The Uninvited: The True Story of the Union Screaming House*. Woodbury, MN: Llewellyn Publications, 2008.

Offutt, Jason. *Darkness Walks: The Shadow People Among Us*. San Antonio, TX: Anomalist Books, 2009.

———. *Haunted Missouri: A Ghostly Guide to the Show-Me-State's Most Spirited Spots*. Kirksville, MO: Truman State University Press, 2007.

Prosser, Lee. *Missouri Hauntings*. Atglen, PA: Schiffer Publishing, 2008.

Bibliography

Rother, Charlotte, and Hubert Rother. *Lost Caves of St. Louis*. Special collector's edition. St. Louis: Virginia Publishing, 2004.

Snyder, Tom. *Route 66: Traveler's Guide and Roadside Companion*. Collector's edition. New York: St. Martin's Griffin, 2000.

Taylor, Troy. *The Devil Came to St. Louis*. Chicago: Whitechapel Productions, 2006.

———. *Haunted St. Louis: History & Hauntings along the Mississippi*. Limited edition. Alton, IL: Whitechapel Productions, 2002.

Terry, Dan. *Beyond the Shadows, Exploring the Ghosts of Franklin County*. Stanton: Missouri Kid Press, n.d.

———. *Missouri Shadows: A Journey Through the Lesser Known, the Famous and the Infamous Haunts of Missouri*. Stanton: Missouri Kid Press, 2008.

Video

Brooks Brothers. *Children of the Grave*. Film. Spooked Productions, www.spookedtv.com.

ABOUT THE AUTHOR

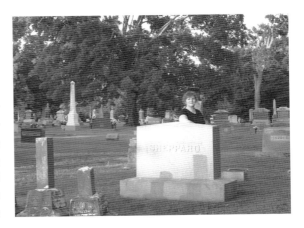

Author Janice Tremeear in Maple Grove Cemetery in Springfield, Missouri. *Courtesy of Dean Pestana.*

Born in St. Louis, Janice has lived most of her life in Missouri. She is a second-generation dowser. In tune with the paranormal from an early age, she now directs her interest and research into investigating the unknown with her team Route 66 Paranormal Alliance. She has three grown children and four grandchildren. She currently lives in Springfield, Missouri.